CHRISTIAN SYMBOLS HANDBOOK

Commentary & Patterns for Traditional and Contemporary Symbols

by Dean Moe

with symbol designs by Avis Benson

Augsburg Publishing House

Minneapolis, Minnesota

CHRISTIAN SYMBOLS HANDBOOK
Cover design by Judy Swanson

Contents

Advent 5

Christmas 12

Epiphany 14

Transfiguration 16

Lent 17

Palm Sunday/Passion Sunday 19

Good Friday 21

Easter 22

Pentecost 26

Trinity 31

Reformation Day 34

All Saints' Day 36

Christ the King 37

Christology 41

The Church 44

Word and Sacrament 46

The Word 48

Holy Baptism 50

Holy Communion 54

Worship 58

Prayer 62

Music 65

Affirmation of Baptism/Confirmation 67

Ordination/Pastors 69

Marriage 70

Family 71

Ministry of Healing 72

Resurrection 73

Evangelism 76

Stewardship 79

Creation 83

Justice 86

Discipleship 92

Index 96

Trumpets

Given the rich symbolism of trumpets, it is odd that handbooks on Christian symbols often do not list them. Throughout history, heralds have announced the coming of a king with the blast of trumpets. They serve the same function in Scripture. For example, trumpets are used to announce the second coming of the Lord, itself a theme of some Advent lessons. "The Lord himself will descend from heaven with a cry of command, with the archangel's call, and with the sound of the trumpet of God" (1 Thessalonians 4:16; compare Matthew 24:31, 1 Corinthians 15:52). In Revelation 8—9, trumpets announce the arrival of the great plagues.

Trumpets also are a means for celebrating God's presence in the temple in Jerusalem. "With trumpets and the sound of the horn, make a joyful noise before the King, the Lord!" (Psalm 98:6). The exuberant doxology concluding the book of Psalms includes this line: "Praise him with trumpet sound; praise him with lute and harp!" (Psalm 150:3). Thus, in Advent the uplifted trumpets can serve both as a call heralding the arrival of the Lord and also as a sign of the joyous festivity found in God's presence.

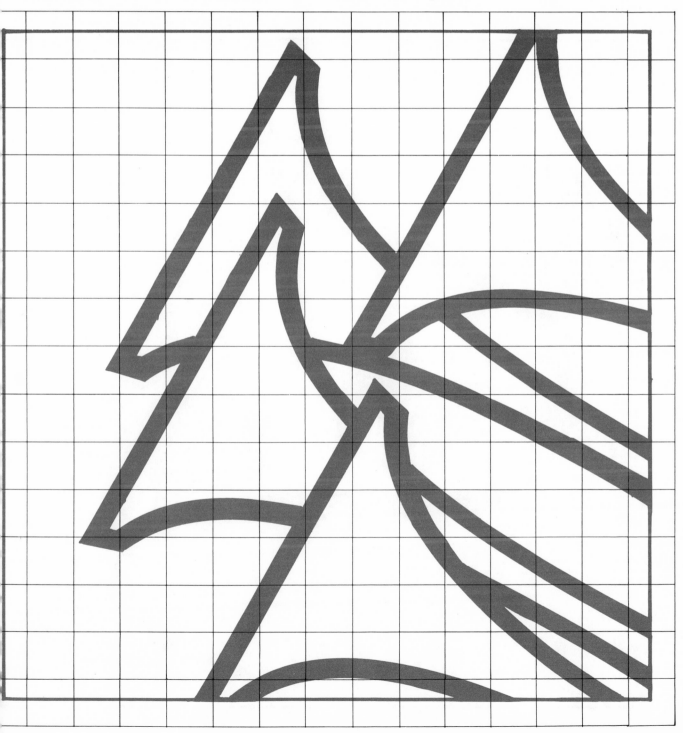

Flames

Flames can remind us of the biblical image of fire as a symbol of God himself, for example in Ezekiel 1:27-28. The Lord appears to Moses as flame in a bush (Exodus 3:2), appears on Mt. Sinai in the midst of fire (Exodus 19:18), and leads Israel in a pillar of fire (Exodus 13:21). The unfolding and developing presence of God during Advent is dramatized by the set of four descending, increasingly large flames.

The Old Testament stories just mentioned and other similar references provide the context for the flames at Pentecost (Acts 2:1-4), symbolizing the promised arrival of God's Holy Spirit bestowed on all believers. That too is appropriate for Advent. The flames remind us of the fundamental role played by the Spirit as the means by which Jesus became present as God's Son in our world in the womb of Mary. The two existing accounts of the birth of Jesus both record this quite crucial role of the Spirit (Matthew 1:18-25; Luke 1—2). The flames thus portray both the role the Spirit played in the incarnation and also the role the Spirit plays in our formation as God's children, in whom God's Spirit dwells and works.

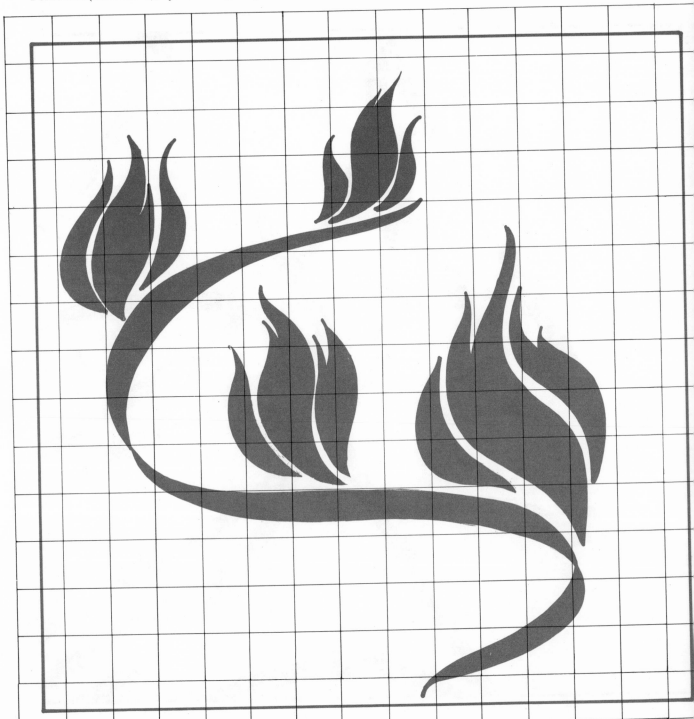

Bells

"The bells of Christmas chime once more; the heav'nly guest is at the door." These opening words of the familiar carol symbolize so well the meaning of bells in Advent. They, like the town crier in past times, announce the news of the coming of the King.

The season of Advent and its four Sundays are portrayed here by four bells. The bells ring joyously to announce a happy event, the coming of the Son of God, the Savior to a needy world.

Bells have often played a role in Christian worship, and can be found as part of the Old Testament worship as well. The high priest's vestments included bells of pure gold (Exodus 39:25).

For many, bells are a sign of celebration used to call God's faithful people to worship. Some parishes still have the old custom of tolling the bell during the Lord's Prayer to signal to those who cannot be present when to join in prayer; in other churches, the bell announces God's presence in the eucharist. In a similar way four bells announce the approaching presence of God and call us to worship that presence with festivity.

Candles

No symbol probably has come to represent the season of Advent more than the Advent wreath. The lighting of a candle for each new week as Advent progresses communicates the time of preparation unfolding and the impending arrival of the birth of Jesus. But the expanding luminosity can signify other important aspects of Advent also. In the northern hemisphere, the season in nature is the time of greatest darkness, the winter solstice. In that context, the gradual spreading of light is a powerful reminder of one of the great themes of the gospel of John, the light of Jesus which overcomes the world of darkness. "The life was the light of men. The light shines in the darkness, and the darkness has not overcome it" (John 1:4b-5). Jesus said, "I am the light of the world; he who follows me will not walk in darkness, but will have the light of life" (John 8:12).

As the Advent season progresses, the light increases until at last Christmas with its news of great joy arrives. The four candles can be used to symbolize the spreading of light in darkness and the progression of time during the four weeks of Advent.

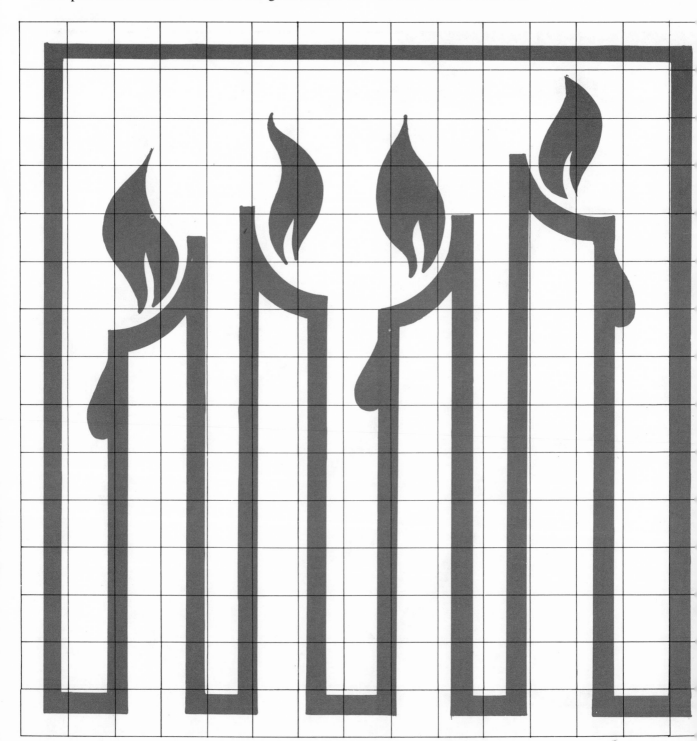

Virgin Mary

The extraordinary experience of the incarnation led Mary through a series of unparalleled events which Luke 1—2 and Matthew 1—2 depict in a way which has captured the world's imagination. The beauty and joy of those events are celebrated; the pain and suffering can be forgotten. There was the danger posed by Herod; there was the exile in Egypt; there was the danger of birth in primitive conditions. But other things were equally troubling and fearful. When the angel greeted her, Mary is reported to have been ''greatly troubled at the saying, and considered in her mind what sort of greeting this might be'' (Luke 1:29). When the shepherds reported the visit of the angels, ''Mary kept all these things, pondering them in her heart'' (Luke 2:19). So much was new; so much wholly unprecedented.

The depiction of Mary here is meant to convey her joy and pondering of all which was happening because of the life developing in her womb. It reminds us that Advent is a time of preparation for us also, as we prepare for the rebirth of God's Son in our hearts, perhaps experiencing dangers which frighten us needlessly when God in fact is shaping new life for us.

Angel

The Bible tells of many times when angels came to people as messengers from God. In the Old Testament we read that angels sometimes came with a word of warning (to Lot in Sodom, for example), or a hand of comfort (to Elijah, fleeing Ahab), or a sword of judgment (to David, when he sinned), or an act of deliverance (to Daniel, in the lion's den).

During Advent we think especially of the angel who came to Mary with a special message: "The child born to you will be . . . the Son of God" (Luke 1:35).

It is interesting to note how often angels appeared in the beginning of Jesus' life on earth (annunciation, Luke 1:26-38; Jesus' birth, Luke 2:8-16; Joseph's dream, Matthew 2:13), just as they did at the end of his life (at the garden of Gethsemane, the resurrection) and will at the second coming.

It is significant that angels repeatedly began with the words, "Fear not," obviously anticipating probable fright which such appearances could evoke. The upraised hand and the scroll convey the angel's message of good news of great joy to all people, that a child has been born, a Savior, who is Christ the Lord (Luke 2:11).

Candles and Dove

This symbol is attractive in its simplicity—four candles and a descending dove. The four lighted candles represent the four weeks of Advent and the waiting in readiness for the appearance of the bridegroom, like the wise maidens with their lamps (Matthew 25:1-13). In many homes and churches the Advent wreath, made up of four candles, is lit regularly during the four weeks which precede Christmas Day.

The dove representing the Holy Spirit is a significant symbol for Advent. Reviewing Matthew 1 and Luke 1—2, one is reminded that the Holy Spirit played a crucial role in effecting Jesus' human birth. The Spirit guided Jesus throughout his ministry, and at Pentecost the Holy Spirit promised by Jesus (John 14:25) came to teach and empower Jesus' followers. The dove can also be regarded as a symbol of the conception of faith in us at Baptism. We are blessed with the Lord's indwelling presence in a manner parallel to the birth of Christ.

The candles represent the anticipation and preparation that are part of Advent. The dove focuses our attention on God's Spirit who prepared the way for Jesus and who prepares us to receive him.

Bethlehem and Holly

"O little town of Bethlehem, how still we see thee lie! Above thy deep and dreamless sleep, the silent stars go by." The familiar carol captures the mood for the modest little town a few miles south of Jerusalem. The beauty of the Son of God being born in such an unpretentious place, however, does not lessen the symbolic and theological importance of Bethlehem.

On the one hand, Bethlehem represents the fact that the God of the Bible acts in history, especially through Jesus. Bethlehem is concrete, factual, historical, and—like other earthly facets of Jesus' life—is subject to scrutiny by all. On the other hand, Bethlehem, the city of Ruth and David, Jesus' ancestors, has a theological significance as the prophesized birthplace of the Messiah (Micah 5:2; Matthew 2:6). Again, history and theology are joined in the biblical account of God's dealings with people.

The holly is not simply a pretty Christmas ornamentation. Its thorny leaves and red berries are traditional symbols of Jesus' passion, and its wood was used for his cross according to legend. It reminds us of the fate awaiting the child born a king.

Manger and Rainbow

For some ancient peoples, the rainbow was a symbol of divine anger, the bow being used to fire arrows of lightning on misbehaving people. In biblical tradition the rainbow was transformed into a symbol of God's faithfulness and love for his vast universe. After purging the earth of sin in the flood, God made the rainbow a sign of his covenant with Noah and all his descendants, that is, with all humanity and all living creatures. Never again, God promised, will God destroy the earth (Genesis 9).

It is unusual to combine this familiar symbol with the Christmas story. To do so, however, serves two purposes. It reminds us how far God ultimately was willing to fulfill his promises. God sent the only Son who was born in Bethlehem to give his life so that people would not perish (John 3:16). The rainbow also symbolizes the fact that the redeeming effect brought about by the birth of God's Son was not confined to the chosen people but, as numerous passages in the New Testament affirm, rather was meant for all peoples and all creation. The rainbow and manger together reflect the powerful themes of God's love and faithfulness for the world.

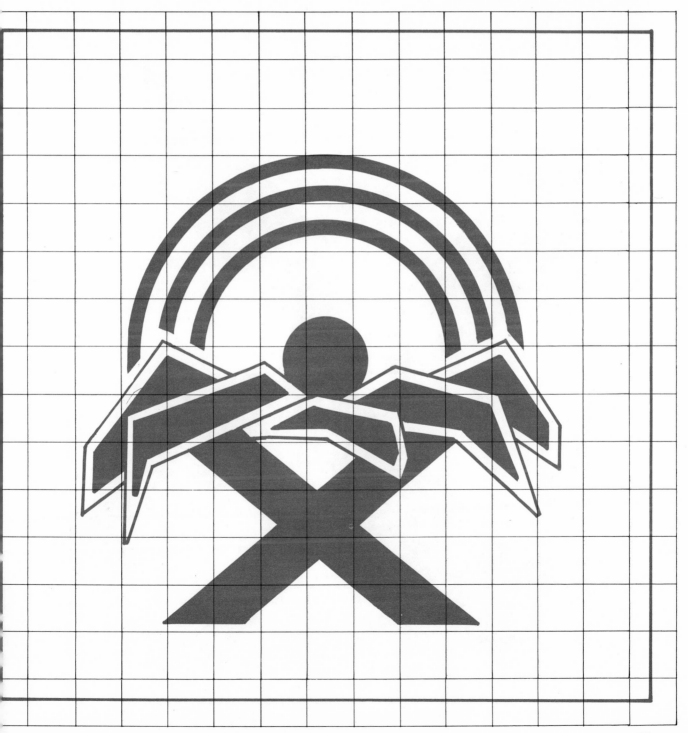

Star

Addressing fallen Jerusalem, the great postexilic prophet in Isaiah 60:1-3 brings a stirring vision of future glory: "Arise, shine; for your light has come, and the glory of the Lord has risen upon you. For behold, darkness shall cover the earth, and thick darkness the peoples; but the Lord will arise upon you, and his glory will be seen upon you. And nations shall come to your light, and kings to the brightness of your rising."

Epiphany means manifestation, the revelation of God's glory in Jesus born in Bethlehem. The symbol represents both the star that guided the Wise Men to the infant Jesus (Matthew 2) and the light overcoming the darkness (Isaiah 60; John 1).

The theme of light over darkness becomes a frequent note throughout the Epiphany season, climaxing in the event which closes the season, the transfiguration, with its emphasis on Jesus' divine radiance and revelation as the Word which surpasses the Law and Prophets in manifesting God's will to the world.

In this depiction, the star and its rays form a cross, reminding us that Jesus, the crucified one, is the focus of the adoration of the world.

Crowns, Gifts, and Star/Cross

Psalm 72 is a prayer for God's blessing on the king of Israel. Speaking of his idealized universal reign, the psalmist says, "May the kings of Tarshish and of the isles render him tribute; may the kings of Sheba and Seba bring gifts! May all kings fall down before him, all nations serve him!" (Psalm 72:10-11). Speaking of the future heavenly Jerusalem and the Lamb in it, Revelation 21:24 portrays kings bringing their glory to it.

Between these past and future times lies the story of the Magi or Wise Men bearing gifts to Jesus, led by the star (Matthew 2:1-12). Because of the Old Testament references, they are often thought to be kings. Because three gifts are mentioned, they are thought to be three persons. Three crowns are pictured with three gifts here. We cannot be certain who these men were, but their questions reveal they were Gentiles. They were part of a class of scholarly, cultured men, perhaps from royal courts. They symbolize the best of the Gentile world adoring Jesus. Epiphany is a season that stresses evangelism, symbolized by four rays for north, south, east and west. The star forms a cross, reminding us that Jesus is the focus of the adoration of the world.

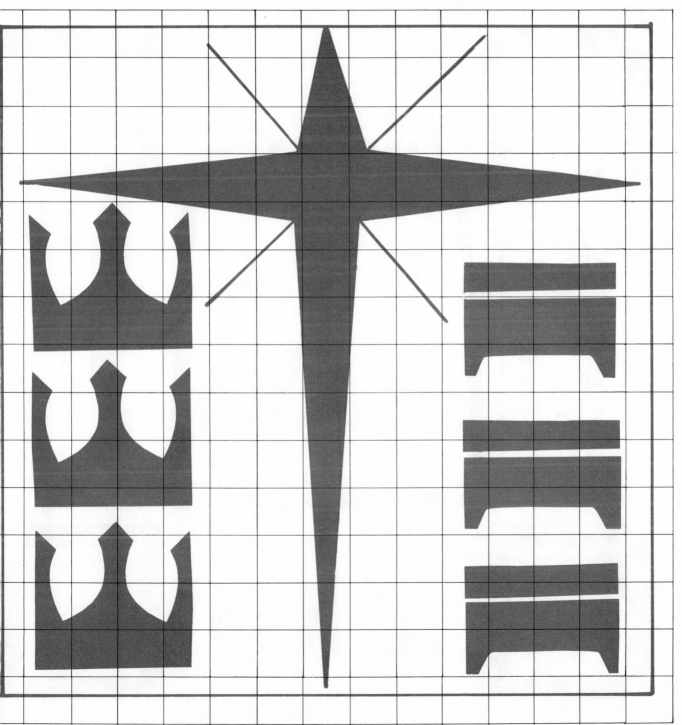

Alpha/Omega, Tablets, and Scroll

The glory of Jesus in the transfiguration is the glory of one who is the revealed Word of God. The story makes the most radical claim about Jesus. He is seen talking to Elijah and Moses who are types or symbols for the two divisions of the Old Testament, the Law and the Prophets.

Peter mistakenly wants to treat Jesus as their equal, but his vision is too narrow. Jesus is not their equal; he far surpasses them as the Word. The heavenly voice first heard in Jesus' baptism boldly asserts, "This is my beloved Son, listen to him!" (Mark 9:7 and parallels).

That assertion combined with the extraordinary transfiguration are what make the story so radical a claim. The design reflects this by subordinating the Law and the Prophets to the Word at the center. This is combined with the imagery of the alpha and the omega from John 1 and Revelation 1:8, 21:6, and 22:13, which together depict Jesus as the Word which was in the beginning, is now, and shall be evermore. The alpha and the omega, the first and the last letters of the Greek alphabet, signify Jesus as the beginning and end of all things, transcending as such the old covenant.

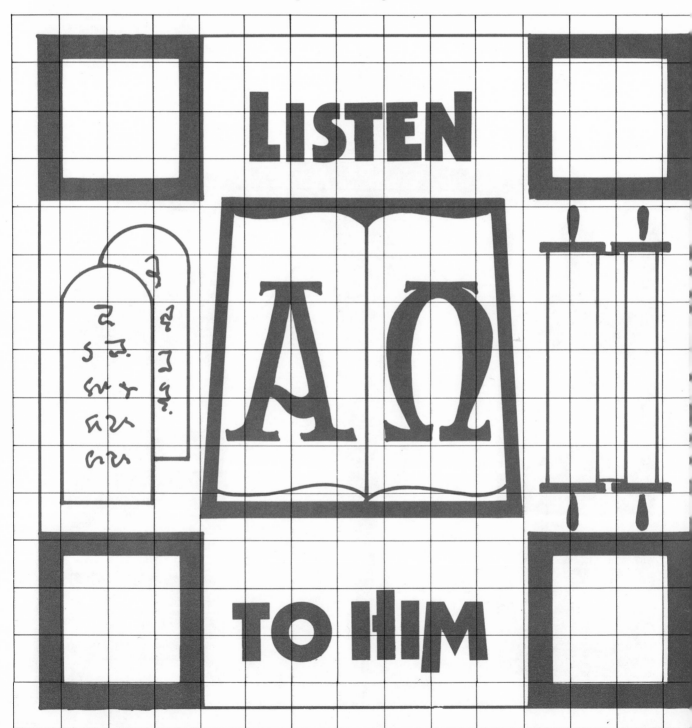

Five Greek Crosses

The cross is central to Lent and indeed is the supreme sign of Christianity. It demonstrates God's sacrificial love for fallen humanity which found its ultimate expression in the death of Christ. It has been stated in fact that this sign has been the most numerous and pervasive sign of all times in the Western world, used in such diverse areas as royal monograms, heraldry, chemistry, trademarks, and official emblems.

There are dozens of variations of crosses, representing various denominations, saints, national cultures, and events. This particular one combines five Greek crosses (the Greek cross having four arms of equal length). A variation of this in turn was used by the crusaders and is known popularly as the Jerusalem cross which has short crossbars at the end of each arm of the central cross. Because the five crosses together represent the five wounds of Christ (hands, feet, and side), it seems especially appropriate as an overall symbol for Lent.

"He himself bore our sins in his body on the tree, that we might die to sin and live to righteousness. By his wounds you have been healed" (1 Peter 2:24).

Cross and Crown of Thorns

The cross is the most well-known, most often used symbol of Christianity. It is at the heart of Lent and Holy Week, as we look ahead to the death of Christ on the cross. The cross is here combined with a crown of thorns, another symbol of Jesus' suffering.

We cannot be certain which of various briers, thistles, or thorny plants were used for the crown. But apart from their use as a fuel to produce hot fires or as protective hedges, like thistles of today they were nasty weeds. This is reflected in Jesus' reference to thorns in the parable of the sower (Mark 4:7, 18 and parallels). In the Bible, such thorns also symbolize at times punishment for sin, for example in Hosea 9:6 and 10:8. All the more ironic, then, that such a symbol should have been placed cruelly upon Jesus' head. For the Roman soldiers who plaited the crown it may not have represented anything extraordinary beyond simple mockery of a man who claimed to be a king.

The crown of thorns is in stark contrast to the green laurel crowns used in athletic games, the crown of roses sometimes worn by emperors, or crowns of precious metals worn by both royalty and wealthy citizens.

Palms and Gate

"They took branches of palm trees and went out to meet him, crying 'Hosanna!' " (John 12:13). What many may regard as a pleasant gesture, waving palms, was a very symbolic and potentially revolutionary act.

Palms and palm trees both were known generally in the Near East and in Israel's own history as religious symbols, and may have represented the Tree of Life. Palms were used in Solomon's temple, as well as in Ezekiel's vision of the temple. Coins issued by the Roman emperors as official propaganda sometimes used palms as a symbol of their victories, a rather common pictorial image in Greek and Roman art. To wave such palms in the incendiary mood of Jerusalem about A.D. 30 may have had major significance in Roman eyes. "Hosanna," a sign of acclamation, could have simply increased this concern.

The arch is a representation of the gates of Jerusalem, through which Jesus entered the city on Palm Sunday. At the same time, it is the typical form of the triumphal arches built by emperors to celebrate victories over peoples such as Israel in A.D. 70. Thus the gate of triumph might also be seen as the gate of threatening power.

Crown, Donkey, and Thorns

"Shout aloud, O daughter of Jerusalem! Lo, your king comes to you; triumphant and victorious is he, humble and riding on an ass" (Zechariah 9:9). This passage is quoted both by Matthew and John to indicate that they saw this prophetic statement fulfilled in Jesus' triumphal entry into Jerusalem. However triumphal, Zechariah was inspired to see the lowliness of it all. Rather than a king typically riding a horse or in a chariot, this king comes riding on an ass, the beast of burden that almost every family owned as the most minimal economic necessity. Tamed already by the third millen-ium B.C., asses were used to carry, to plow, to ride, and to sell. Yet, then as now, they could represent the most lowly of animals. Some king, riding on an ass!

This symbol of lowliness is combined with the double representation of the two crowns to emphasize the paradox of Palm Sunday: triumph and suffering, exaltation and humiliation. The crown of thorns surrounds the king's crown and the donkey, indicating the path that was necessary was the way of suffering, the way of the cross. Even the king's crown, a sign of triumph, has a cross above it.

Rooster and Thorns

Despite numerous other variations in details concerning Jesus' suffering and death, it is interesting that all four Gospels include in their accounts the detail regarding Jesus' prophecy that Peter would deny the Lord three times before the cock crowed. Peter had so confidently stated, ''Though they all fall away because of you, I will never fall away,'' and 'Even if I must die with you, I will not deny you'' (Matthew 26:33, 35). Yet when the danger became real, Peter denied three times that he ever knew Jesus (Matthew 26:69-75 and parallels).

Like many other details concerning Jesus' last earthly days, this event led easily to a symbol, one of denial and betrayal in this case. That symbol, the rooster, is here joined with that of thorns, a traditional symbol of Jesus' suffering. The rooster became a kind of herald to announce the suffering that was to follow. Usually a rooster is associated with an announcement of increasing light, the dawn; but here the meaning is a dark one. The cock and thorns are joined together as a solemn reminder of Jesus' last days, abandoned by friends and facing a cruel death.

Pomegranate, Sun, and Laurel

Pomegranates were one of three types of fruit the spies brought back to Moses as evidence of the abundance of the promised land (Numbers 13:23). It also was a common religious symbol in the Near East in antiquity. The pomegranate had significance for Israel too. The high priest's robe included pomegranates (Exodus 28:33-34). The symbol carried over into Christianity, where the bursting of the fruit and release of the seeds became a symbol of the resurrection, Jesus' bursting forth to new life from the tomb. The symbol here is combined with the sun, another symbol of the first Easter morning.

Surrounding the central panel is a laurel wreath or crown, given to the victor in athletic contests. Paul referred to this trophy in 1 Corinthians 9:24-25 and also in 2 Timothy 2:5. The crown of laurel here is a contrast to the crown of thorns forced upon Jesus prior to his crucifixion. The thorns were a sign of humiliation; the laurel is a sign of exaltation, a symbol of victory and eternity because its foilage does not fade like that of other plants. "When the chief Shepherd is manifested, you will obtain the unfading crown of glory" (1 Peter 5:4).

Easter Lilies

The white Easter lily has served for centuries as a symbol of Easter. The various terms translated "lily" in the Bible probably do not refer to this particular lily. Certainly there is agreement that the "lilies of the field" to which Jesus compares Solomon's glory (Matthew 6:28; Luke 12:27) are most probably the lovely masses of wild, brilliant flowers such as poppies and anemones which cover the meadows and hillsides each spring. But the springing forth of such lovely beauty from a seemingly dead mass (the bulb) and the symbolic purity of its color have come to represent the resurrection.

Here the four lilies form a cross-like shape similar to the cross fleurée (each of the four arms of the cross ends in three petals) which is one of the many variations of the universal symbol of the cross. The cross is here transformed from death to life, from decay to great beauty and new beginnings by means of the much beloved form of the Easter lily. The four leaves, reminiscent of palm leaves, form a second cross. Palm Sunday's acclamation of royalty led to Good Friday, but from that dark day came victory. The palm leaves too declare new life.

Peacock

Peacocks are natives of India introduced into the Near East and eastern Mediterranean world sometime in the first millenium B.C., yet there is no reference to the bird in the Bible. Nevertheless, they frequently are portrayed in early Christian art as a symbol of the resurrection and immortality. According to legend, the flesh of the peacock was incorruptible; the annual renewal of the splendid feathers also symbolized new life. Often associated with gardens where their beauty is an added adornment, they can be seen as a promise of the life to come in the heavenly garden we call paradise. Their inherent beauty, combined with the early tradition of their symbolizing the resurrection make them a very appropriate symbol for Easter.

The peacock symbol was common in the catacombs where the early Christians hid during early persecutions. The message of Jesus' victory over death and the resurrection gave them hope as they faced an uncertain future. The peacock is found often in Byzantine art.

Other variations of the symbol of the peacock include a peacock standing on an orb symbolizing the world, and two peacocks drinking from vases of water.

Tree of Life

In the beginning, the Tree of Life was part of a story leading to Adam and Eve's disobedience and death. To eat it was to live forever; thus it was forbidden to Adam and Eve after the fall (Genesis 3:22-23).

In Revelation's vision of paradise to come, the situation is precisely reversed. "To him who conquers, I will grant to eat of the tree of life, which is in the paradise of God" (Revelation 2:7). In Revelation 22:2, the tree of life stands in the middle of the heavenly Jerusalem, a means of healing for the nations. The same section combines the presence of the tree with that of

light: "And night shall be no more; they need no light of lamp or sun, for the Lord God will be their light, and they shall reign for ever and ever" (Revelation 22:5).

These composite images of the tree of life and the sunless light which is Christ are combined here as a symbol of Easter. The tree takes the form of a cross, which in Christ becomes the supreme tree which bestows life. He who was crucified says, "I am the light of the world; he who follows me will not walk in darkness, but will have the light of life" (John 8:12).

Dove

The dove or turtledove are smaller varieties of various kinds of pigeons known in the Near East. In Genesis 8 a dove returned to Noah with the olive sprig, the sign that the floodwaters had receded. In the law of Moses, the turtledove was the most inexpensive offering allowed (Leviticus 5:7, 11). The dove is a symbol of beauty and love in the Song of Solomon. And in Matthew 10:16, Jesus finds the dove a symbol of innocence. Yet none of these provide a clear context for the dove being chosen to symbolize the Spirit in Jesus' baptism.

All four gospels record the appearance of the dove after Jesus was baptized (Matthew 3:13-17; Mark 1:9-11; Luke 3:21-22; John 1:31-34). That picture has captured the attention of Christians and has been used by the church to represent the coming of God's Spirit. The dove is perhaps the most universal symbol used to represent the Spirit, the third member of the Trinity.

The dove represented here is a descending dove. Wings outspread, it descends from the heavens as in Jesus' baptism.

Hand, Flames, and Sun

"And Mount Sinai was wrapped in smoke, because the Lord descended upon it in fire" (Exodus 19:18). God has been revealed through fire in various biblical events. God appeared to Moses in the burning bush (Exodus 3:1-6). God was a pillar of fire leading the Israelites by night (Exodus 13:22). God appeared to Abraham as a "smoking fire pot and a flaming torch" (Genesis 15:17). Ezekiel in his vision saw God on his throne as fire (Ezekiel 1:26-28).

The dramatic story of Pentecost, when the very Spirit of God was dispensed to all the disciples as tongues of fire, has its background in such biblical events and metaphors. Through the image comes one of the most radical claims of the New Testament: that God himself now dwells personally among his people, the church (Acts 2). The imagery of the Spirit's fire here is reinforced by the background of a flaming sun, a metaphor for Christ. Malachi 4:1-2 says that "the sun of righteousness shall rise, with healing in its wings." The tongue of flame descends upon the outstretched hands of a believer lifted in the traditional gesture of supplication and submission to what is being received.

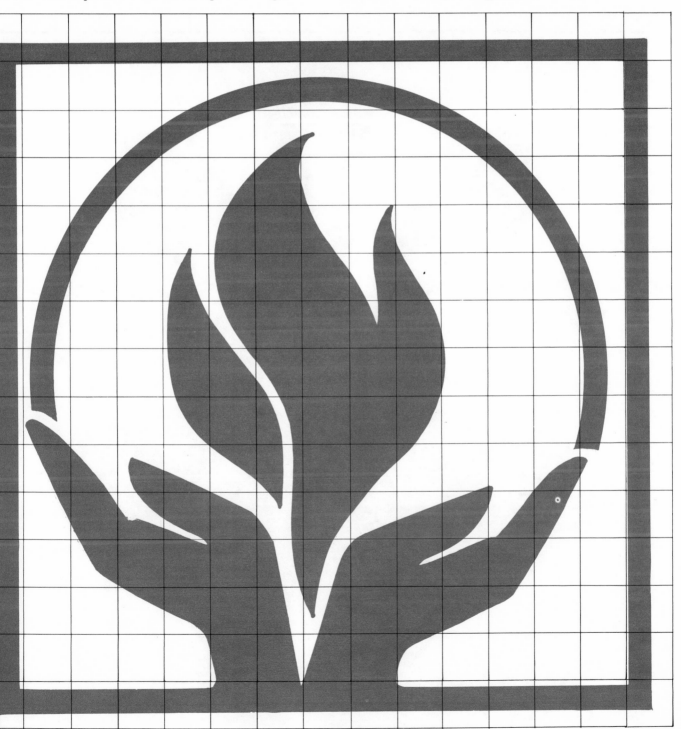

Fruits of the Spirit

Paul writes, "The fruit of the Spirit is love, joy, peace, patience, kindness, goodness, faithfulness, gentleness, self-control" (Galatians 5:22-23). These nine kinds of fruit are contrasted with the seven gifts of the Spirit (see p. 44) in symbolism. Various devices have been used to symbolize the nine kinds of fruit.

Galatians is the text always cited in this regard, but it is of interest that Paul in 1 Corinthians 12:4-11 also lists nine varieties of service or work done by Christians. In that context, he stresses that whatever the different varieties of gifts, all are bound together in the unity of the one Spirit.

The idea of diversity within unity here is symbolized by the form of the daisy. The daisy itself sometimes is used as a symbol of innocence and unassuming, familiar beauty. The nine petals representing the nine kinds of fruit are joined together through the center medallion. In the center is the dove, representing the Spirit, the one who enables the fruit to come forth. Christians by themselves cannot be loving, joyful, kind, good, and so forth, but as the Spirit of God works in them, their lives increasingly show forth the fruit of the Spirit.

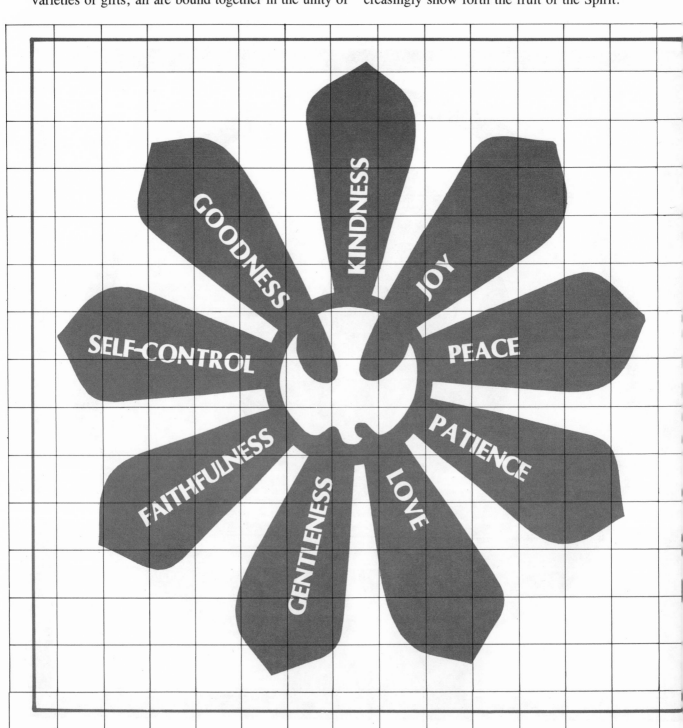

Plant and Sun

The festival of Pentecost is followed by a period of time encompassing several months when the liturgical color is green and the appointed texts do not follow a consistent theme. This period is thought of as a time of growth and nurture in the Spirit. It is the time of the church year between Jesus' past earthly ministry and his second coming in triumph, celebrated at the end of the long green Season after Pentecost. As a symbol of this period in the church year, one can use the two motifs which nature provides as symbols of growth, a new plant and the sun. Both of these signs from nature have biblical foundations for the meaning of the season.

The sun represents Christ, the light of the world: "I am the light of the world; he who follows me will not walk in darkness but will have the light of life" (John 8:12). The term "sun of righteousness" from Malachi 4:2 is often interpreted as a prophetic reference to Jesus, and the sun has been used as a symbol of Jesus' resurrection, a reminder of Easter morning. The plant represents believers who derive their light and life from Christ (the cross at the center); they abide in him as the branches abide in a life-giving vine (John 15:1-11).

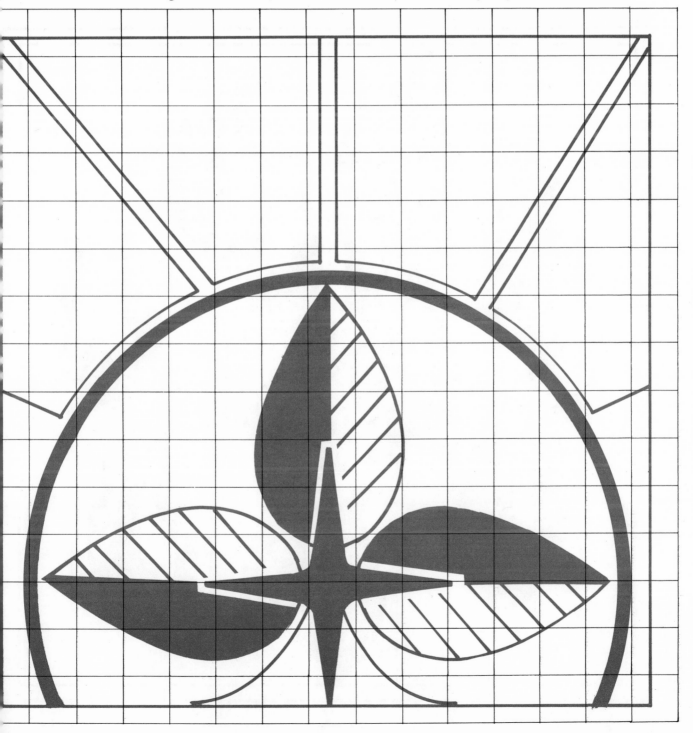

Dove and Flames

Isaiah refers to the messianic king: "The Spirit of the Lord shall rest upon him, the spirit of wisdom and understanding, the spirit of counsel and might, the spirit of knowledge and the fear of the Lord" (Isaiah 11:2).

In the old covenant period, that Spirit had been thought to be confined to the king, to prophets, to charismatic leaders only. But the prophet Joel foresaw a time when the Spirit's presence and gifts would be universal: "It shall come to pass afterward, that I will pour out my spirit on all flesh" (Joel 2:28). Peter at Pentecost saw the Spirit's coming as the realization of Joel's vi-

sion. So the sevenfold gifts of the Spirit also came to be seen as applying not only to Christ, but also to all Christians. This concept is reflected in the baptismal service where the seven gifts are included in the invocation of the Spirit.

Here the seven flames of the gifts form a circle representing eternity; they are everlasting. The swooping dove and flames suggest "the rush of a mighty wind" at Pentecost (Acts 2:2-3). The seven flames also recall the "seven torches of fire, which are the seven spirits of God" in John's vision (Revelation 4:5).

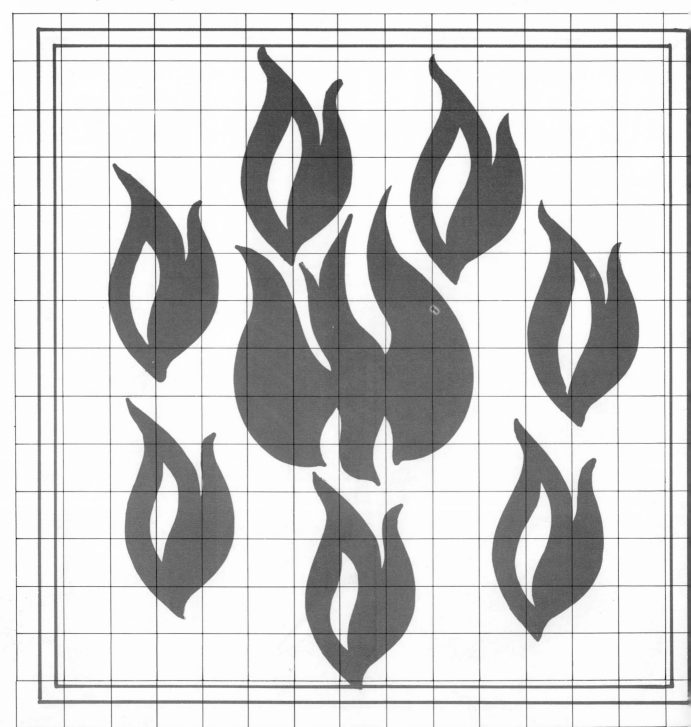

Triangle and Trefoil

The foundations for the doctrine of the Trinity are laid in the activities of the Father, Son, and Holy Spirit recorded in Scripture. As the church struggled to comprehend what had been accomplished and revealed in Christ and in the bestowal of the Spirit, it summarized its understanding in the great ecumenical creeds, notably the Nicene and Athanasian Creeds. To communicate this faith, the church for centuries had relied on geometric figures in particular to convey the great paradox of a God who is "three in one, one in three." These figures either are used alone or in interwoven combinations as shown here.

Of all the symbols for the Trinity, the equilateral triangle perhaps is the most common. The three equal angles and three equal sides reflect the equality of the three persons of the Trinity, while the resulting single figure of the whole triangle demonstrates their unity.

The triangle here is interwoven with a trefoil figure. The profile of the trefoil is derived from that of the shamrock or clover with its three lobes and from the interlocking set of three circles, both also symbols of the Trinity.

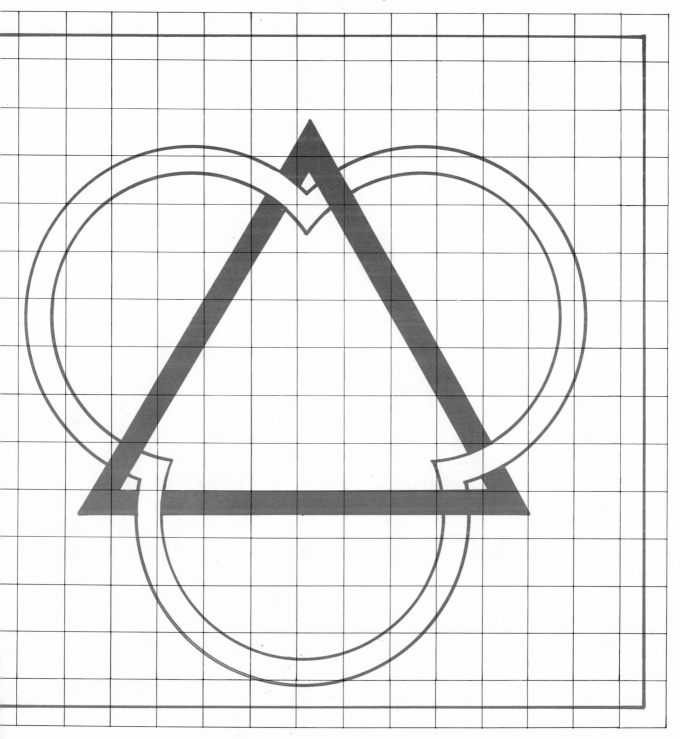

Triquetra, Triangle, and Sanctus

In 742 B.C., Isaiah had a vision of the Lord sitting upon his throne. Above the Lord stood the seraphim calling to one another, ''Holy, holy, holy is the Lord of hosts; the whole earth is full of his glory'' (Isaiah 6:3). Similarly, in his vision of God, John saw four living creatures around the throne who sang day and night without ceasing, ''Holy, holy, holy, is the Lord God Almighty who was and is and is to come!'' (Revelation 4:8). The words ''holy, holy, holy'' early on became a symbol for the Trinity and are the basis for the *sanctus* (in Latin *sanctus* means ''holy''), a canticle

incorporated in many eucharistic liturgies.

Combined with the *sanctus* here is another common symbol of the Trinity, the triquetra. The triquetra is a three-pointed triangular figure portraying the ''three-in-one'' of the Trinity. Three *vesicae,* almond or fish-shaped forms, result from three interlocking circles. Their interwoven, continually flowing nature reflect the unity of the Trinity; the three points the three persons. It early became a symbol for the Godhead.

Both the center of the triquetra and the surrounding border form triangles, also symbolizing the Trinity.

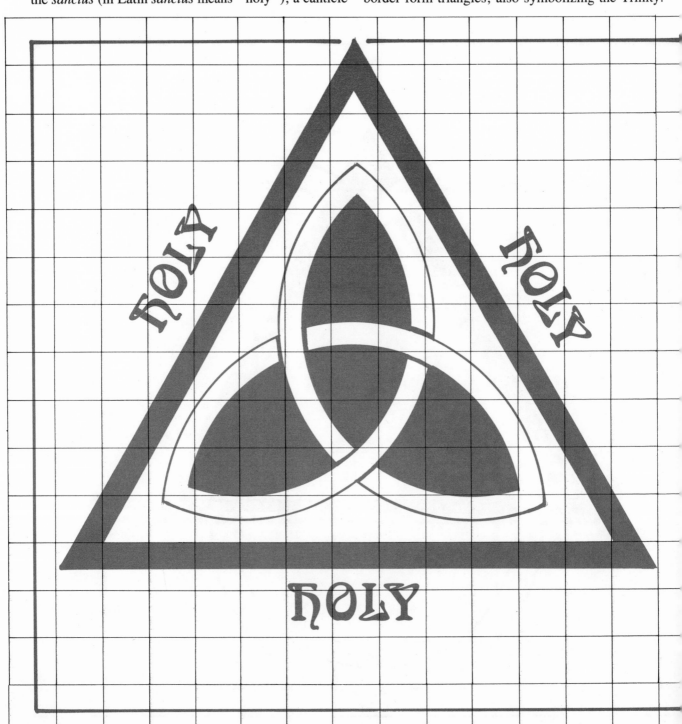

Heart and Circles

The circle by itself is used often to designate God's eternal existence. Having no end or beginning, the circle conveys such a meaning. Three circles intertwined as shown here, on the other hand, are used to symbolize the Trinity. Equal circles reflect the equality of the three persons; being intertwined as here reflects the indivisibility of the Trinity's unity. The symbolism is enhanced by the triquetra formed at the center by the three circles (see page 32). Finally, as circles, we see the coeternity and interdependence of the Trinity.

The three circles here are set in a heart. As John 16—17 demonstrates, the highest, most profound love known is that which the Father, Son, and Spirit manifest among themselves and to the creation. Jesus closes his prayer in John 17 by asking that ''the love with which thou hast loved me may be in them and I in them'' (John 17:26). 1 John also speaks of that great love: ''Beloved, let us love one another, for love is of God, and he who loves is born of God, and knows God . . . for God is love'' (1 John 4:7-8). The heart combined with the trinitarian symbol serves to remind us of that love.

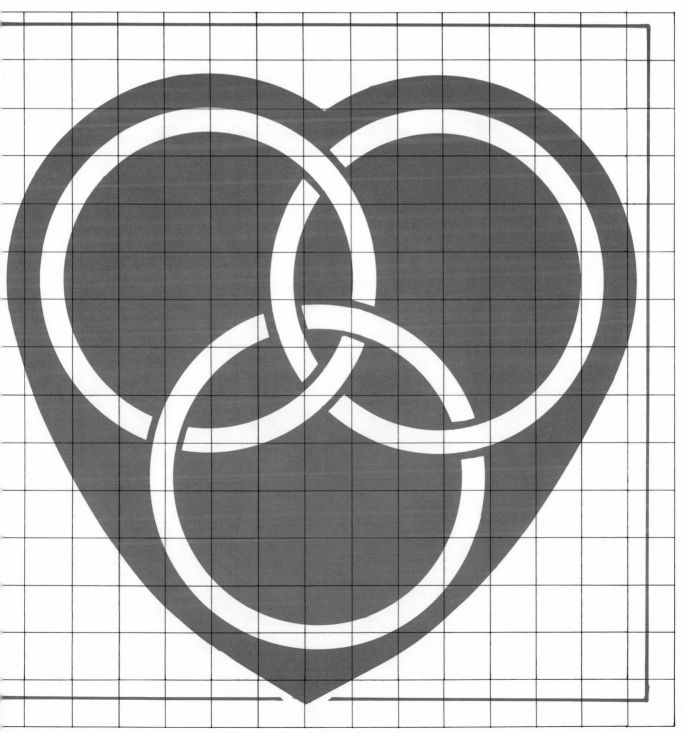

Luther's Seal

The coat of arms which Martin Luther designed for himself has become the most common symbol for the observance of Reformation Day and is often used among churches accepting the Lutheran confessions. At the center stands a Latin cross, the three upper arms of equal length, the lower section of the upright extended. The cross is centered in a red heart, a symbol for the great love of God. The heart is placed within a white rose with five petals.

Luther said that the cross is meant to remind us that "it is faith in the Crucified that saves us. . . . This heart should be set in the midst of a white rose, to show that such faith yields joy, peace, and comfort." The rose is set on a blue field representing heaven. The blue in turn is surrounded by a golden ring, symbolizing eternity.

It was the book of Romans that spoke most clearly to Luther that faith is reckoned to us as righteousness (Romans 4:5), and that "since we are justified by faith, we have peace with God through our Lord Jesus Christ" (Romans 5:1). Luther wanted to communicate that the joy derived from faith is an anticipation now of the heavenly joy which shall last forever.

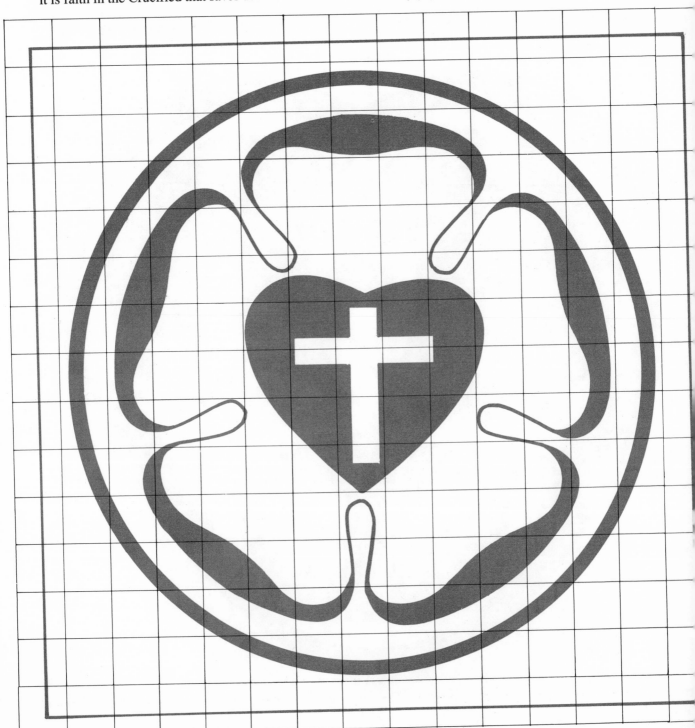

Fortress

"God is our refuge and strength, a very present help in trouble" (Psalm 46:1). Though various psalms speak of God as a fortress (Psalm 18; 31; 59; 62; 71; 91; 144), it was Psalm 46 which inspired Martin Luther to write and compose *"Ein feste Burg"* ("A Mighty Fortress"). The image of God as a fortress was real to Luther even in a physical sense. In 1521-1522, a few years before this hymn was composed, Frederick the Wise, Luther's guardian prince, had put Luther in safekeeping in the ancient Wartburg castle to protect him from his enemies.

Luther included in the hymn mention of threats from both earthly ills and from the prince of darkness, but he affirmed that God never fails, no matter what form the adversarial forces take. Confiding in our own strength would be useless, but God's own Son, Jesus Christ, had already won the battle.

After its composition, the hymn rapidly assumed widespread popularity among the followers of the Reformation. Today it has become a great ecumenical hymn as well, translated into 200 languages and dialects and included in hymnals of many denominations.

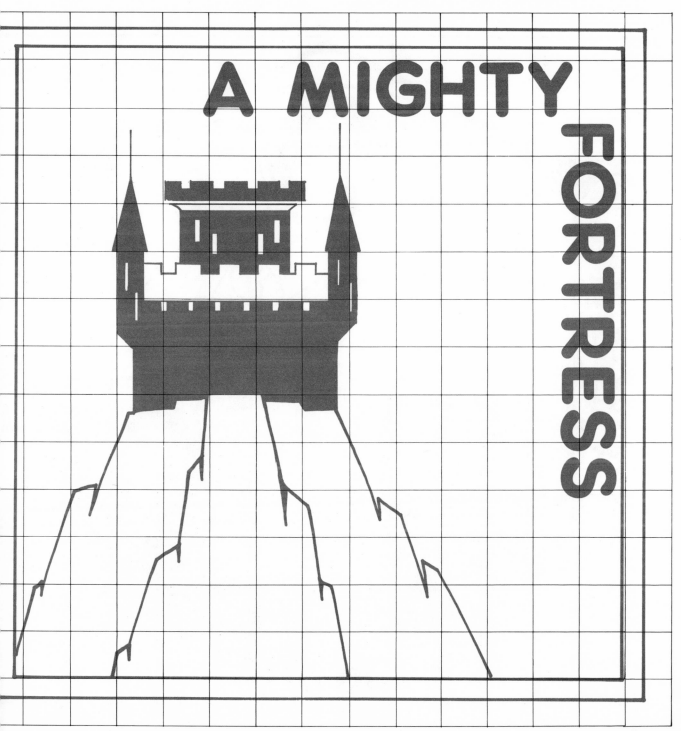

Angel, Trumpets, and Cemetery

Addressing opponents who denied the resurrection of the body, Paul in 1 Corinthians 15 provides one of the earliest and most extensive discussions of that doctrine. In that context he writes, ''Lo! I tell you a mystery. We shall not all sleep, but we shall all be changed, in a moment, in the twinkling of an eye, at the last trumpet. For the trumpet will sound and the dead will be raised imperishable, and we shall be changed. . . . When the mortal puts on immortality, then shall come to pass the saying that is written: 'Death is swallowed up in victory.' '' (1 Corinthians 15:51-55).

In this symbol the trumpets sound over a cemetery to raise those who are sleeping, that is, those who have died. An angel of the Lord carries the soul of a saint into heaven. At the trumpet's sound, the saints are raised to new life. Death is at last abolished. ''Thanks be to God who gives us the victory through our Lord Jesus Christ'' (1 Corinthians 15:57). The cemetery is rounded like a globe to suggest that our fallen world is the realm of death until that new day comes. ''For as in Adam all die, so also in Christ shall all be made alive'' (1 Corinthians 15:22).

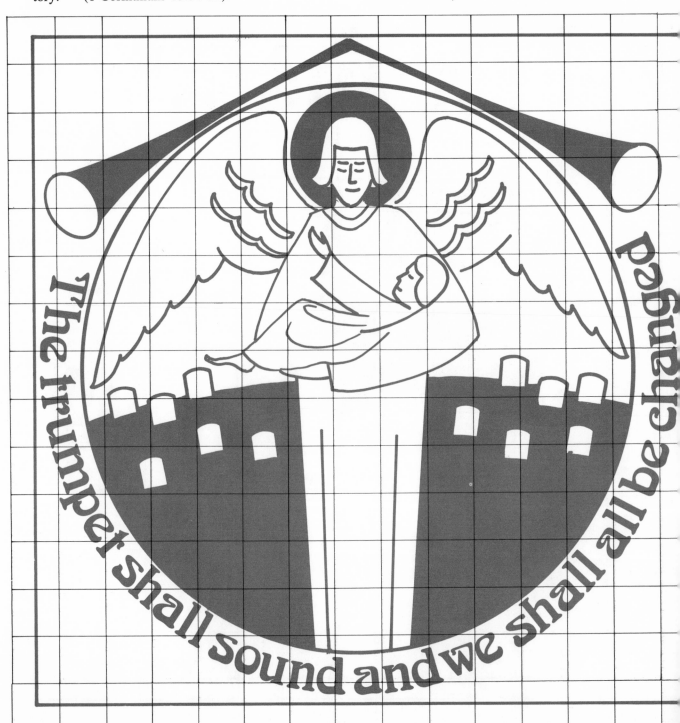

Palms and Crown with Cross

The title "Christ" quickly became a name for Jesus even during the biblical period, and many today think of it simply as a surname. Christ originally is the Greek translation of Messiah, which literally means "the anointed one." The Messiah was the king who would come in the end time, appointed by God to restore the fortune of his people Israel. When the title was applied to Jesus, the church was claiming that he indeed was this king. Its importance is shown by the fact that it is the most common title for Jesus in the New Testament. The church year festival of Christ the King reflects this view of Jesus as Messiah, Christ, King.

While Messiah or King is a common title for Jesus, there really is only one reference in the New Testament to his wearing a crown. Revelation 14:14 describes the last judgment. "Then I looked, and lo, a white cloud, and seated on the cloud one like a son of man, with a golden crown on his head." The "son of man," a title Jesus often used for himself, is indeed Christ, the anointed one, the king. The palms are a symbol of victory. The cross on the crown is a reminder of the cost of the victory.

Trumpets, Cross, and Orb

The titles applied to Jesus in the New Testament are extremely significant. They reveal much about both Jesus' essence (who he is) and his functions (what he does). Accordingly, numerous scholarly articles and books have been devoted to the subject. Yet in Christian symbolism very little use has been made of these titles. (The fish, combining the titles "Christ," "Son of God," and "Savior," is the one important exception.)

On All Saints' Day, when the church celebrates Jesus' final triumph, it seems appropriate to honor Jesus with some of the most important titles in Scripture, as shown in this design. The titles are clustered around the orb representing the earth, surmounted by the crown, signifying Jesus' rule of all. The four trumpets are intimately linked with Jesus' second coming in triumph. The gospel of Matthew describes Jesus' coming: "And he will send out his angels with a loud trumpet call, and they will gather his elect from the four winds, from one end of heaven to the other" (Matthew 24:31). The four trumpets can represent both the four titles and the four corners of the globe, suggesting Jesus' reign over the entire world.

Enthroned Christ

"The Lord sits enthroned for ever, he has established his throne for judgment; and he judges the world with righteousness, he judges the peoples with equity" (Psalm 9:7-8). "Thus says the Lord: 'Heaven is my thone and the earth is my footstool' " (Isaiah 66:1).

Such biblical images early were combined with the ritual of the imperial court to show Jesus enthroned, wearing a crown. This symbol illustrates that kingship. Seated, the ruler is prepared to exercise authority. He holds the orb, symbol of royal power and of the globe. The earth takes the place of the customary footstool or cushion used by earthly rulers.

Christ, Son of God and Son of man, in his flesh unites the two worlds of heaven and earth in his birth and in his second coming as King. His royal power further is symbolized by the three crowns, reminding us of the Magi who represented the world at Jesus' birth. The crowns form a cross, the sacrifice which is the foundation of Christ's rule.

For the faithful, Jesus' coming and judgment is not a sign of condemnation but of hope; thus, Jesus raises his hand in benediction.

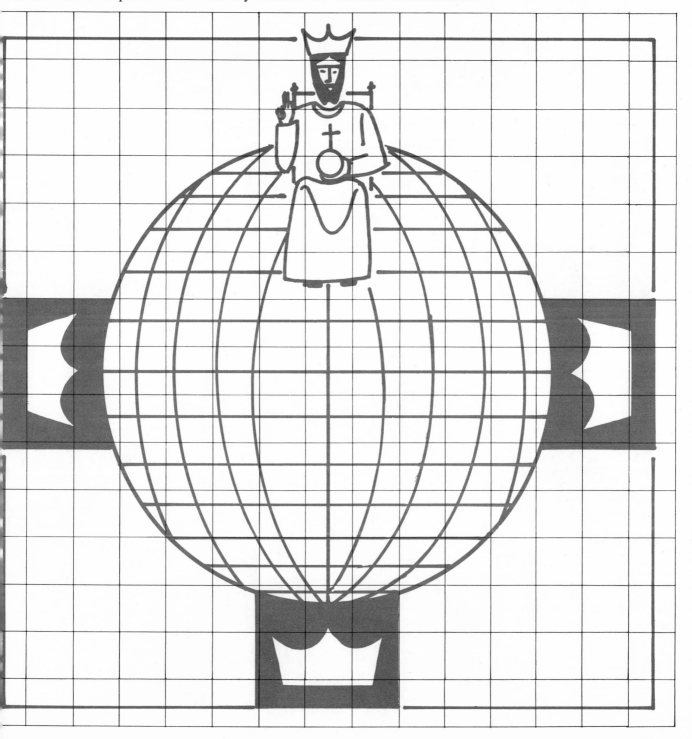

Triumphant Christ

The triumphant Christ often is portrayed as here, wearing a crown with his hands held out in a gesture of greeting and welcome. The halo signifies his new heavenly state of glory. In Revelation, we read that thousands sang, "Worthy is the Lamb who was slain to receive power and wealth and wisdom and might and honor and glory and blessing" (Revelation 5:12).

From the figure extend rays which also convey Jesus' new glorified status. The rays form the first letters of the Greek words, Jesus Christ, the I and X. These letters when used together serve as one of the earliest and most common monograms for Christ. Here the monogram is combined with a crossbar, thus incorporating the symbol of the cross.

Although Jesus lived a humble life of servanthood, before he was born it was said of him, "He will be great and be called the Son of the Most High . . . and of his kingdom there will be no end" (Luke 1:32-33). During his life on earth, he "emptied himself, taking the form of a servant . . . he became obedient unto death, even death on a cross" (Philippians 2:5-11). But now Jesus is exalted, the gracious and triumphant king.

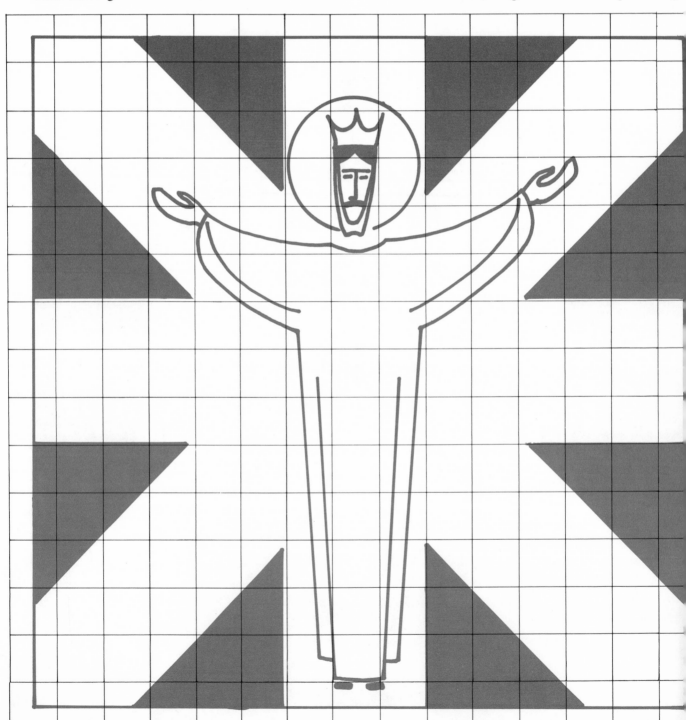

Hourglass and Alpha/Omega

"Thus says the Lord, the King of Israel and his Redeemer, the Lord of hosts: 'I am the first and I am the last; besides me there is no god' " (Isaiah 44:6). The use of the first and last letters of the Greek alphabet, alpha and omega, symbolizes this concept of God as everlasting. In Revelation, Jesus applies it to himself: " 'I am the Alpha and the Omega,' says the Lord God, who is and who was and who is to come, the Almighty" (Revelation 1:8; see also 21:6 and 22:13). In a similar train of thought, the gospel of John begins with the famous lines, "In the beginning was the Word

He was in the beginning with God; all things were made through him, and without him was not anything made that was made" (John 1:1-3). The words, "I am the beginning and the end," provide a frame for the symbol and reinforce its message.

These great assertions of Jesus' divine essence and rule here are combined with a reminder of his finite existence on earth and ours—the hourglass. The hourglass literally measures each hour at a time, an ancient device for timekeeping. Finitude and infinitude are joined in Christ.

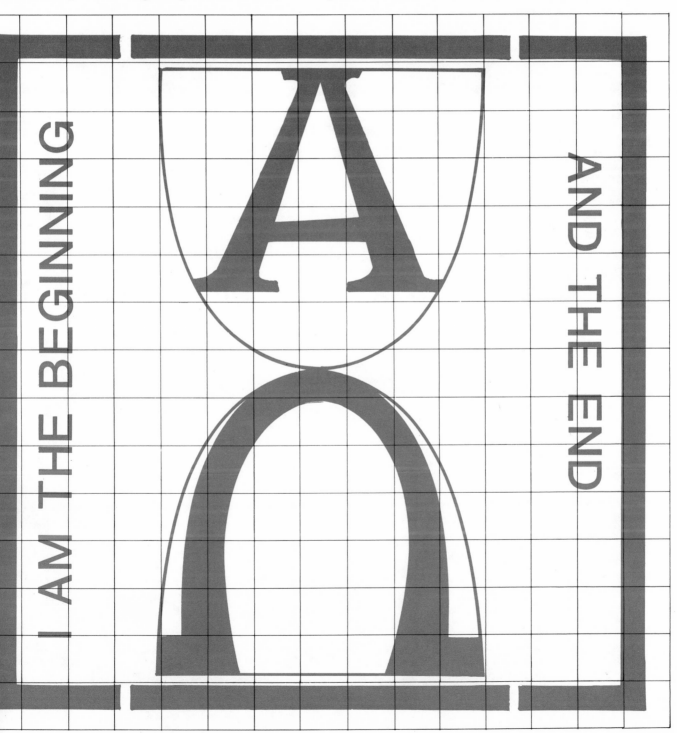

I AM THE BEGINNING

AND THE END

Lamb and Angels

"And between the throne and the four living creatures and among the elders, I saw a Lamb standing, as though it had been slain. . . . And when he had taken the scroll, the four living creatures and the twenty-four elders fell down before the Lamb . . . and they sang a new song, saying, 'Worthy art thou to take the scroll and to open its seals, for thou wast slain and by thy blood didst ransom men for God from every tribe and tongue and people and nation, and hast made them a kingdom and priests to our God, and they shall reign on earth' " (Revelation 5:6-10). The same praise was voiced by John the Baptist when he saw Jesus for the first time: "Behold the Lamb of God, who takes away the sin of the world!" (John 1:29).

In the great transformation of Passover, Christ substituted himself for the lamb slain to save people. For this, he is praised forever. The lamb's standing position, the rayed halo, and the banner here all represent his final victory. The four angels, which in classical art could represent the four winds or four seasons, here face the Lamb in adoration, symbolizing the fabulous heavenly acclamation.

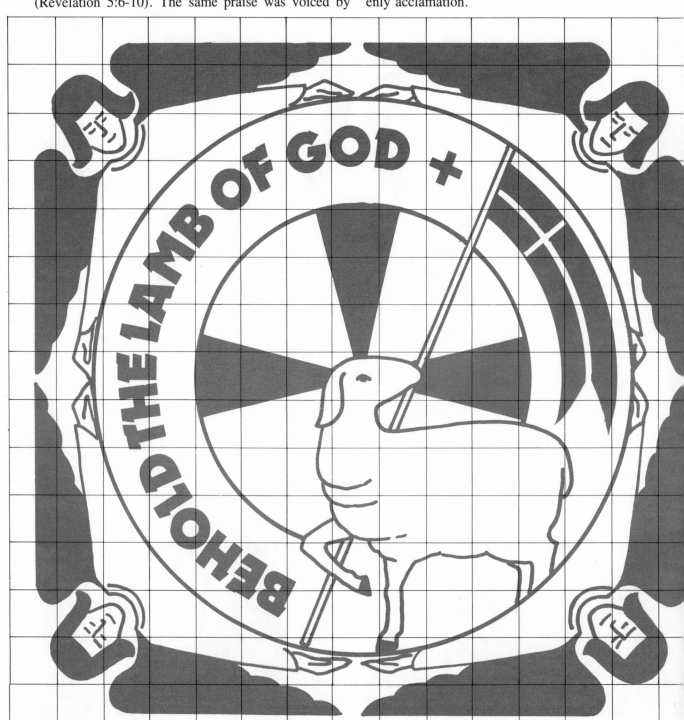

Shepherd and Lamb

The two most extended biblical allegories of the shepherd are Ezekiel 34 and John 10. In Ezekiel 34:15-16, the Lord God says, ''I myself will be the shepherd of my sheep. . . . I will seek the lost . . . bring back the strayed . . . bind up the crippled . . . strengthen the weak, and the fat and the strong I will watch over; I will feed them in justice.'' Jesus applies this to himself in John 10, but with an addition which is inconceivable in the Old Testament tradition. Jesus says, ''I am the good shepherd. The good shepherd lays down his life for the sheep.'' Others might die, but no one ever anticipated that God's Son should die as stated here by Jesus.

Very early in the catacombs the good shepherd became one of the most common representations of Jesus. He is the one who leaves the 99 to search out the one lost sheep (Luke 15:3-7; Matthew 18:12-14) and who has compassion on the people who are like sheep without a shepherd (Mark 6:34). The crucial relationship between vulnerable sheep and the shepherd becomes an exalted and beloved picture of God's relationship to his people.

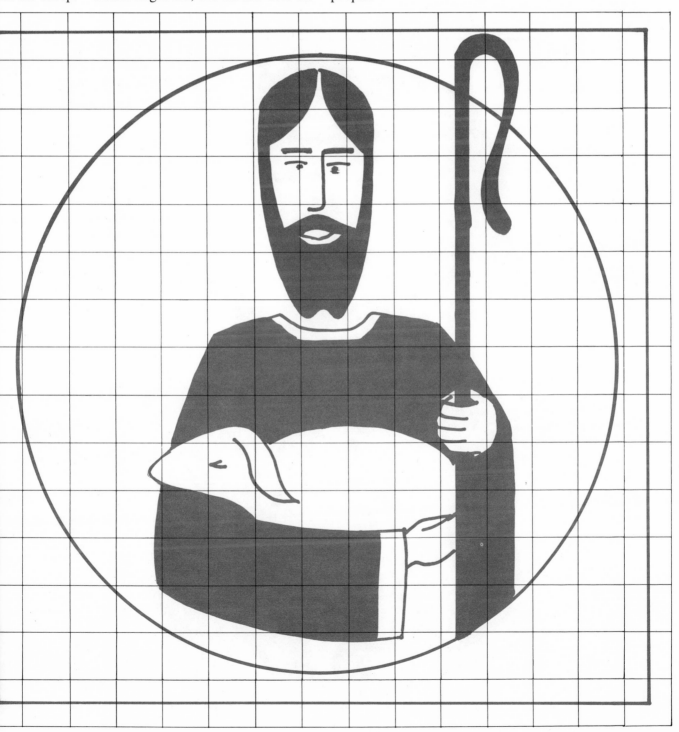

Flames and World

The church was given birth on Pentecost with the bestowal of the Holy Spirit (Acts 2). Thus, in this symbol the flames of the Spirit come to rest on the heads of the seven figures surrounding them. The seven points of the flame and the seven-pointed star formed by the figures refer to the seven gifts of the Spirit—wisdom, understanding, counsel, might, knowledge, fear of the Lord, and joy in God's presence—first mentioned in Isaiah 11:2-3.

The seven figures are an ancient symbol in Christian art. As such, they often are represented in portrayals both of the eucharist and of the heavenly feast, inspired by the story of Jesus' postresurrection appearance to the seven disciples recorded in John 21. The figures join hands as a symbol of the church's unity for which Jesus prayed in his famous high priestly prayer in John 17. The figures form the perimeter of a circle, which—along with the four compass points—suggest the universal and globe-encompassing nature of the church mandated by Jesus in his Great Commission (Matthew 18:19-20). Thus, the church's beginnings and final destiny, its unity and universality, all are encompassed in this symbol.

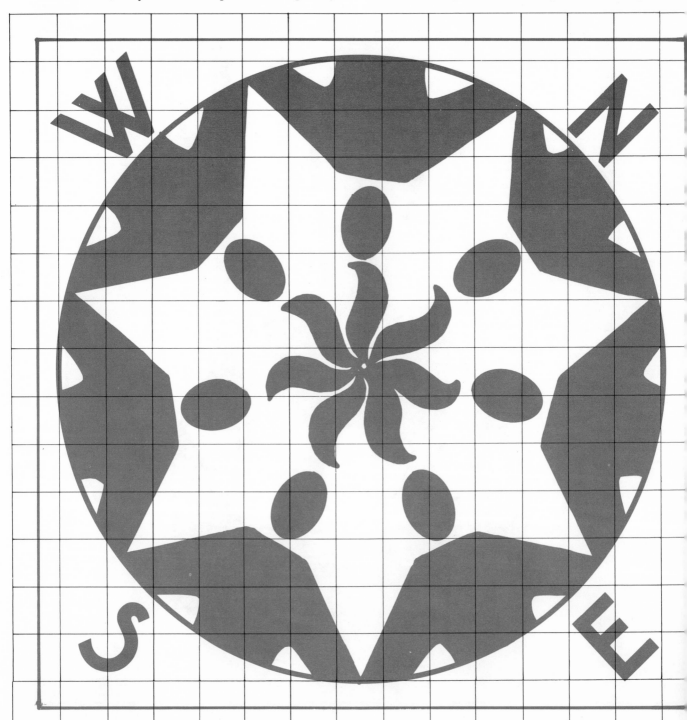

Ship, Dove with Branch, and Rainbow

Early in the church's history the boat became a symbol for the church. Even today a lifelike model of a boat hangs in some churches which have a Scandinavian heritage. The word "nave"—which designates the central section of the church building between the aisles, with the door at the back and chancel at the front—comes from the Latin word for ship (cf. "navy"). The people sitting or standing in the nave are the cargo of the ship, the church! Some of this symbolism is derived from the famous miracle of Jesus' stilling of the storm (Mark 4:35-41 and parallels). Jesus as Lord of nature preserved the boat and disciples from sinking. The image came to mean much to early Christians who, despite persecution and difficulties, knew they would prevail, thanks to the Lord. Here that promise is reinforced by combining the ship with the rainbow and dove bearing an olive branch, elements in the story of the flood (Genesis 6:5—9:17). The dove with olive branch signifies the promise of arrival safely home. The rainbow is a symbol of God's faithful promise to preserve the earth, and in this case the church. Thus, however threatening the church's experience, it lives by the promises of God.

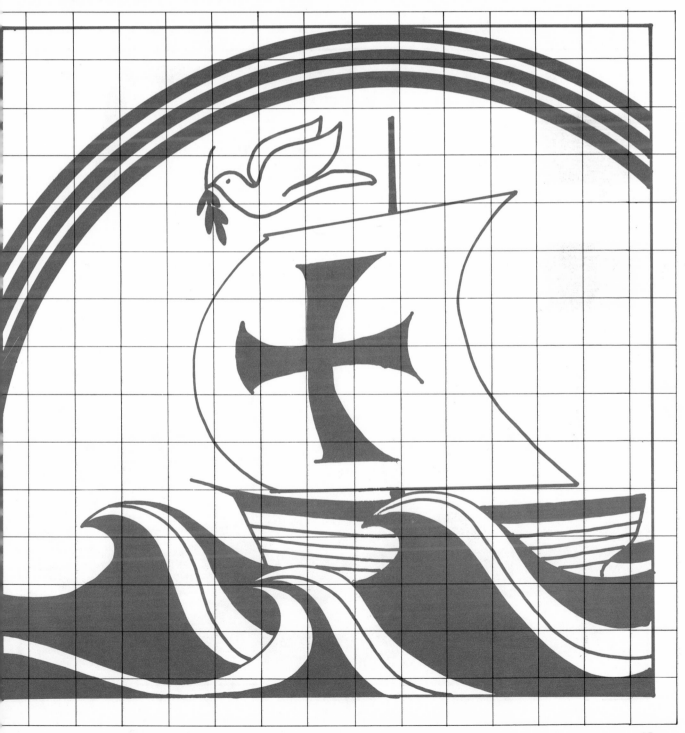

Bible, Chalice, and Water

Word and Sacrament are the constitutive elements in the church's life in Christ. By them the church is sustained and nourished. Word and Sacrament also are the two traditional segments of the liturgy. Various traditions have differing numbers of sacraments, depending on how that term is defined. But the two that are central to worship itself are the two instituted by Christ, the two which have overwhelmingly central significance in the church's history and in ecumenical life today, that is, Baptism and the eucharist.

Both are clearly commanded by Jesus. When he com- missioned his followers to go and make disciples, he told them to baptize in the name of the Father, Son, and Holy Spirit (Matthew 28:19). In the upper room, he instituted the Lord's Supper and told his disciples to ''do this in remembrance of me'' (1 Corinthians 11:24).

Thus, the book which here symbolizes the Word is combined with symbols for these two sacraments, the chalice for the Lord's Supper and waves (water) for Baptism. The bread of the eucharist is shown above the chalice. The form of the chalice itself suggests hands reaching for the bread.

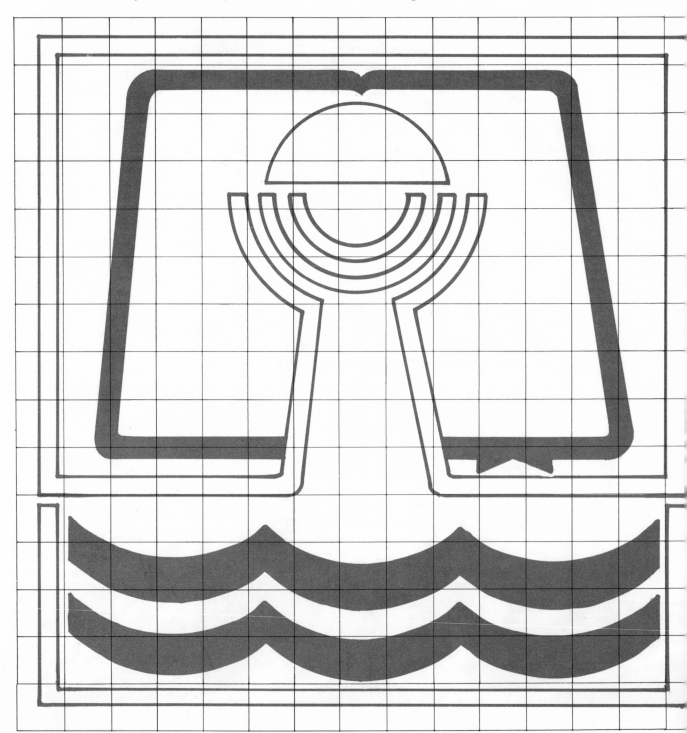

Bible, Dove, Water, Word, Chalice, and Bread

This symbol focuses on the Word, symbolized by an open Bible, and the Sacraments. The drops represent the sacrament of Baptism; the chalice and bread, the eucharist. The dove representing the Holy Spirit is the presence of God which makes all these earthly elements efficacious means of grace. "For by one Spirit we were all baptized into one body—Jews or Greeks, slaves or free—and all were made to drink of one Spirit" (1 Corinthians 12:13).

The means of grace, Word and Sacrament, are founded on Christ's sacrifice on Calvary. And so in this symbol the various elements are joined by the cross at the center, a form of the cross cercelée. (With the cross cercelée, the end portion of each arm divides and curves.)

The sections formed by the extension of the cross's arms shape four hearts. The hearts remind us how profoundly the gifts of the Spirit, the Scriptures, Baptism, and the eucharist portray the love of God. "So we know and believe the love God has for us. God is love and he who abides in love abides in God, and God abides in him" (1 John 4:16).

Bible

This simple design reminds us that Christ is *the* Word, as expressed in John 1:1-18: "In the beginning was the Word, and the Word was with God, and the Word was God." It is Christ alone whom we worship as the Word of God. In that context, we revere the Scriptures; we do not worship them. However, the collection of books, letters, and other writings which we call the Bible (Bible means "book" in Greek), however secondary and subordinate to Christ, have the highest authority for the faith and life of the church as the revealed Word of God. It is this human, earthly collection of writings, inspired by the Spirit working in people's lives in history, which gives us the record of God's ways with his people and world. God uses this means, like the sacraments, to make his presence with us.

And so the story of the church in many ways is one of God's people discovering over and over again the riches of grace both in old and new ways as history unfolds. This written and proclaimed Word which brings life is one of the mountain peaks of each Sunday service, along with the sacraments. It is the foundation for daily devotions and life.

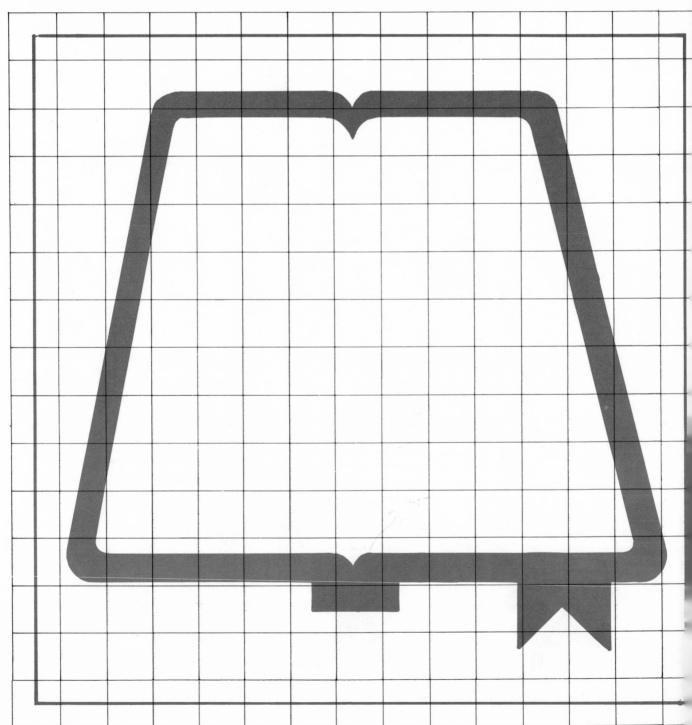

Bible and Symbols of Four Seasons

The Word is for all seasons—the seasons of the year, the seasons of our pilgrimage on earth, the beginning of time and the end of time. These thoughts are conveyed by this symbol. The four articles from nature represent each of the four seasons: a flower for spring, a green leaf for summer, ripe grain for fall, a snowflake for winter.

The four panels themselves form a cross which is the center of our faith and the most important message of the Bible. The Bible provides the structure for the whole symbol and is shown open and accessible to all. It speaks to us in all the seasons of our lives—from our childhood when we willingly receive it, through our youth and adult years when we both struggle with its meaning and look to it for direction, and into our later years when it gives us comfort and hope.

As a familiar hymn expresses it: "O Word of God incarnate, O Wisdom from on high, O Truth unchanged, unchanging, O Light of our dark sky: We praise you for the radiance that from the hallowed page, a lantern to our footsteps, shines on from age to age."

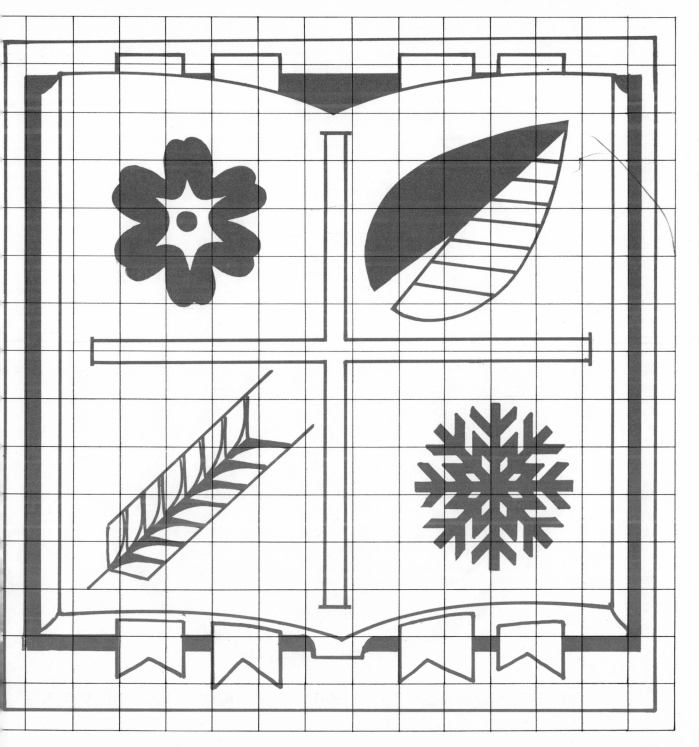

Drop of Water and Dove

"In the beginning God created the heavens and the earth. The earth was without form and void, and darkness was upon the face of the deep; and the Spirit of God was moving over the face of the waters" (Genesis 1:1-2). These famous opening lines of Genesis, describing God's creation of the world, often have been compared to the recreating power of the water and Spirit in Baptism. In both, God uses the two elements, earthly water and divine Spirit, to create life out of chaos. Both were essential ingredients in Jesus' own baptism by John in the Jordan River: "Jesus . . . was baptized by John in the Jordan. And when he came up out of the water, immediately he saw the heavens opened and the Spirit descending upon him like a dove" (Mark 1:9-10). Based on this remarkable experience recorded in all four gospels, the dove has become a symbol for the Spirit.

In Jesus' conversation with Nicodemus, he said, "Truly, truly, I say to you, unless one is born of water and the Spirit, he cannot enter the kingdom of God" (John 3:5). Both water and Spirit are represented in this symbol. Here the descending dove combines with a representation of a drop of water.

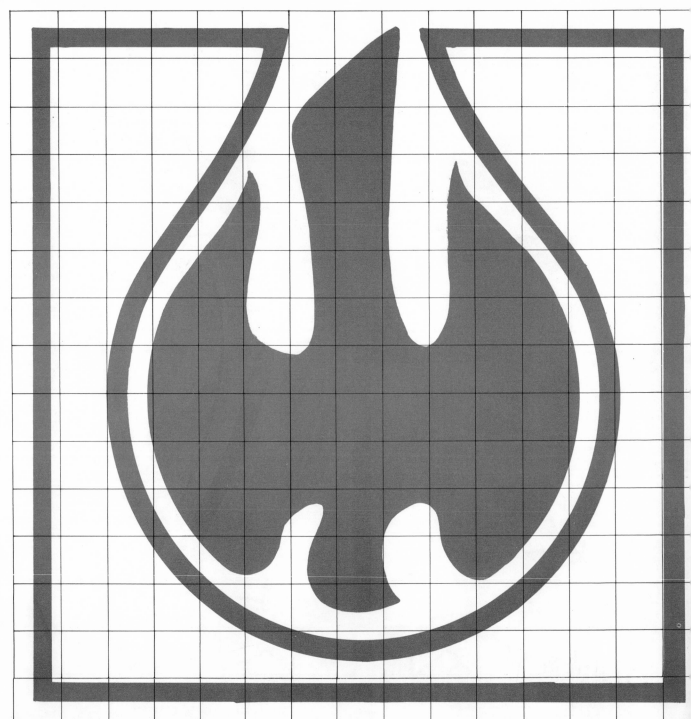

Dove and Water

Here the sacrament of Holy Baptism is represented by the dove and water.

A clear connection between water, represented by waves, and the Spirit, represented by the dove, is found in John 3:5: "Unless one is born of water and the Spirit, he cannot enter the kingdom of God." Water implies cleansing, as in Titus 3:5 which refers to "the washing of regeneration and renewal in the Holy Spirit." Romans 6:3-4 even seems to suggest drowning: "All of us who have been baptized into Christ Jesus were baptized into his death. We were buried therefore with him by baptism into death, so that as Christ was raised from the dead by the glory of the Father, we too might walk in newness of life."

Baptism is a celebrative event that has meaning for every day of our lives. Each day we are cleansed and renewed; each day we are empowered by the Spirit. Baptism is a gift of grace which, though individually received, unites us to the whole Christian family whom the Spirit makes one: "There is one body and one Spirit . . . one Lord, one faith, one baptism, one God and Father of us all" (Ephesians 4:4-6).

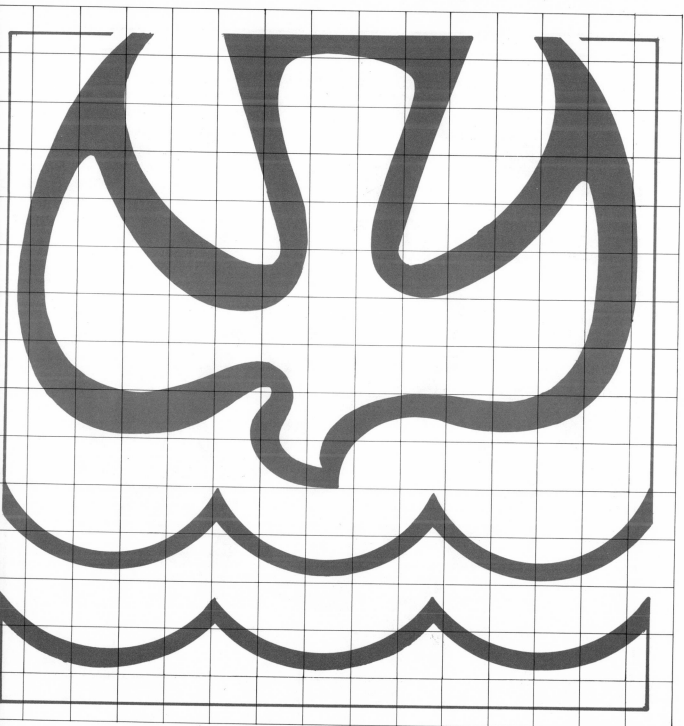

Shell

The ancient pagan symbol of the shell as a sign of fertility and deification was adopted, as were many motifs, for use in early Jewish and Christian art. Used in tombs, architecture, and art, the shell became a symbol of immortality. In this context, with its related marine associations, it has become a symbol of Baptism. Curiously enough, the shell also has become a symbol of pilgrimage. In the symbol for St. James the Elder, the shell has that significance.

The shell in the symbol is the scallop shell with its hinge, deeply grooved, with a ridged edge. When the hinge is at the top of the design as here, the shell's ridges also can remind us of the rays of divine light streaming down, sometimes suggesting a halo. The three drops representing the earthly element of water in the sacrament also can remind us of the Trinity. We are baptized in the name of the Father, Son, and Spirit (Matthew 28:19).

The shell and water together unite the profound realities of Baptism as our birth as God's children and Baptism as a beginning of the process of pilgrimage where we daily are born again in the Spirit.

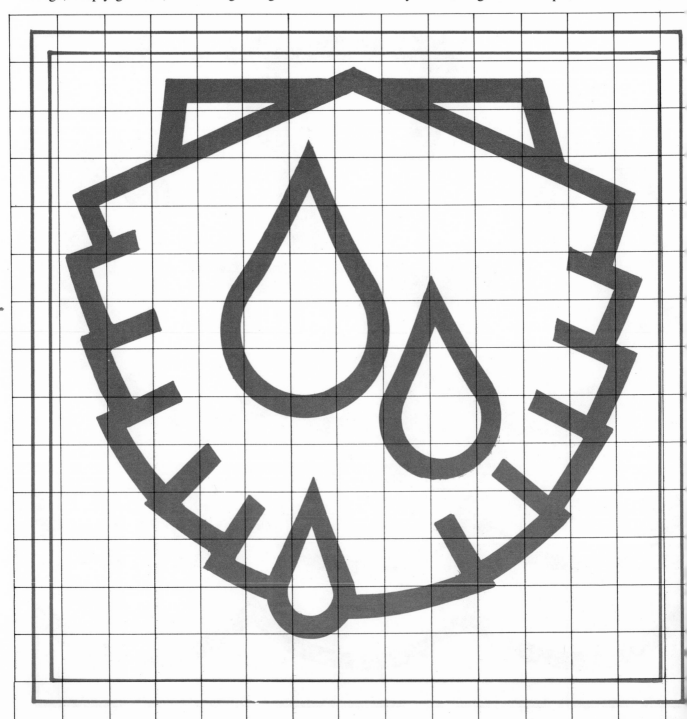

Water, Flames, and Dove

The waves and dove remind us of the story of the flood which God sent to cleanse the earth of sin (Genesis 6—9). The flood is a type or symbol of Baptism, when we die to sin and are raised to new life in Christ (1 Peter 3:19-22; Romans 6:3-11).

Like the flood, the crossing of the Red Sea (Exodus 13:17—14:31) also is a symbol for Baptism. God used the Red Sea as a means of deliverance, freeing God's people from slavery in Egypt. Baptism frees us from the slavery of sin.

In that exodus, there was not only water but also fire, for God led his people by a pillar of fire. Fire, often a symbol of God's presence, also symbolizes the coming of the Holy Spirit at Pentecost and in Baptism.

All these elements are brought together in the prayer of thanksgiving in the baptismal liturgy, when we give thanks for the ways in which God has used water to bring life: "By the gift of water you nourish and sustain us and all living things." The dove carrying the olive branch represents the new life to come for Noah and for us. The seven flames symbolize the seven gifts of the Spirit.

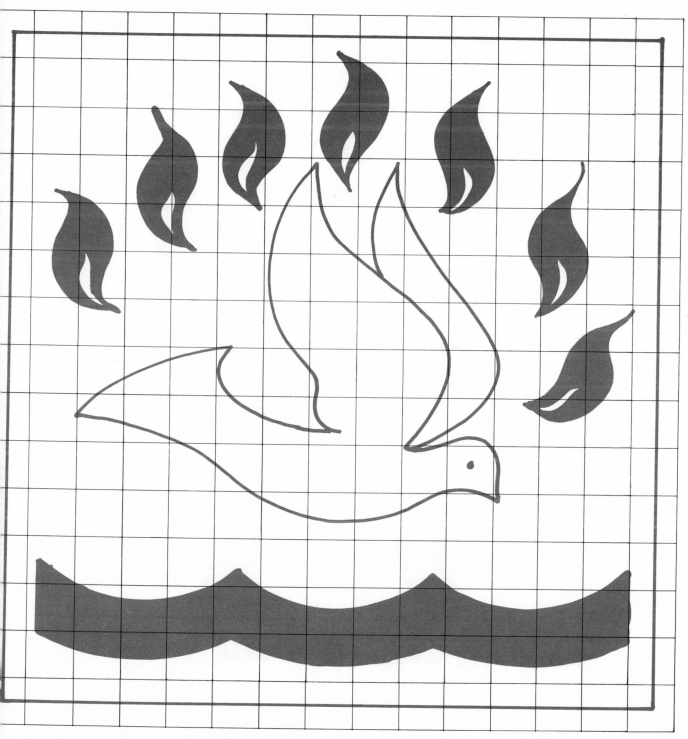

Chalice and Wafer

Bread and wine, the two central, earthly elements in the Lord's Supper or eucharist, here are represented by the chalice and wafer. The two elements were part of the Passover meal which Jesus transformed into the eucharist.

A drinking cup filled with wine was used as part of the ritual for Passover. "He took a cup, and when he had given thanks he gave it to them, and they all drank of it. And he said to them, 'This is my blood of the covenant, which is poured out for many' " (Mark 14:23-24).

The bread is portrayed here as it often was in early Christian art. It may actually have reflected the manner in which the bread was folded. In any case, the round loaf with superimposed cross quickly became a symbol for the eucharist. The two together, chalice and bread, very early took on another significance as well. "The cup of blessing which we bless, is it not a participation in the blood of Christ? The bread which we break, is it not a participation in the body of Christ? Because there is one bread, we who are many are one body, for we all partake of the one bread" (1 Corinthians 10:16-17).

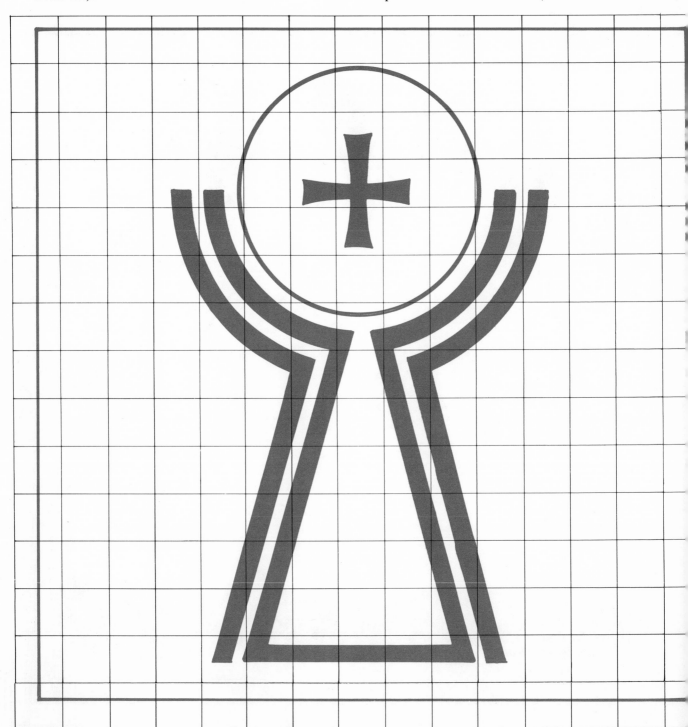

Chalice, Bread, and Bible

In this symbol the symbols of bread and wine for the eucharist are united with the book symbolizing the service of the Word. The eucharist and the Word are two chief components in the liturgy of the church. In both, God uses earthly elements—human language and products of the fields—to share himself with us. In both we hear the good news of forgiveness and grace, the gospel.

The book can also represent the Word who became flesh among us, Christ. As the gospel of John states, "In the beginning was the Word, and the Word was with God, and the Word was God. . . . And the Word became flesh and dwelt among us, full of grace and truth; we have beheld his glory, glory as of the only Son from the Father" (John 1:1, 14). Christ the Word gave himself, his flesh and blood, for us and shares himself with us in the gift of the eucharist.

" 'This is my body which is for you. Do this in remembrance of me. . . . This cup is the new covenant in my blood. Do this, as often as you drink it, in remembrance of me.' For as often as you eat this bread and drink this cup, you proclaim the Lord's death until he comes" (1 Corinthians 11:24-26).

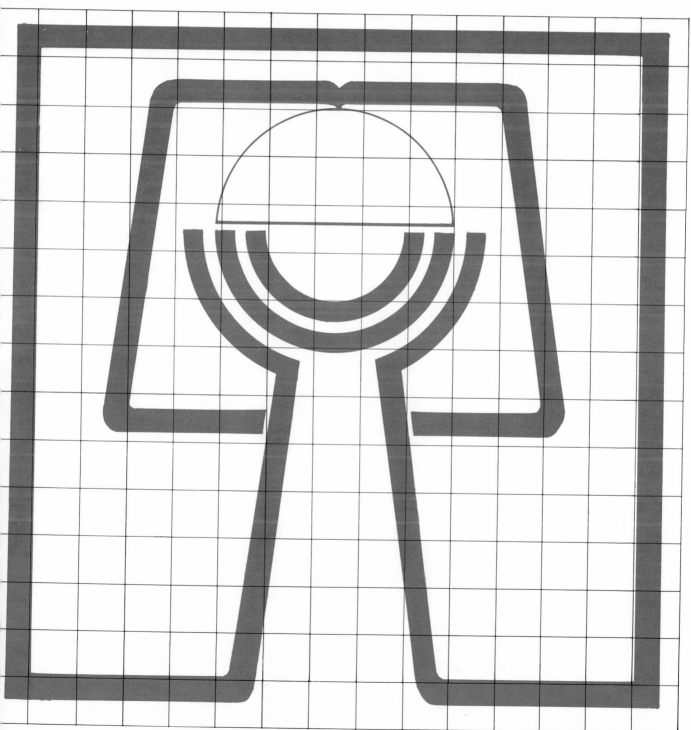

Chalice and Grapes

In *The Small Catechism*, Martin Luther describes the benefits received in the Lord's Supper: "forgiveness of sins, life, and salvation." Then he asks, "How can eating and drinking do all this?" And this is his answer: "It is not eating and drinking that does this, but the words, *given and shed for you for the remission of sins.* These words, along with eating and drinking, are the main thing in the sacrament. And whoever believes these words has exactly what they say, forgiveness of sins." For the individual believer, those words, "for you," are absolutely crucial. Only by believing them can one know the benefits of this lavish gift of God.

From that point of view, the symbol here can represent three separate aspects: (1) There is the world of nature, the grapes. (2) Jesus transforms the fruit of the vine into his own blood. (3) When we drink the wine and hear and trust the words, "shed for you," we receive life and salvation. The same words apply to all our brothers and sisters around the world who come to the Lord's table and believe these same words. Much more than an individual act of piety, the Lord's Supper is global and universal and transcendental!

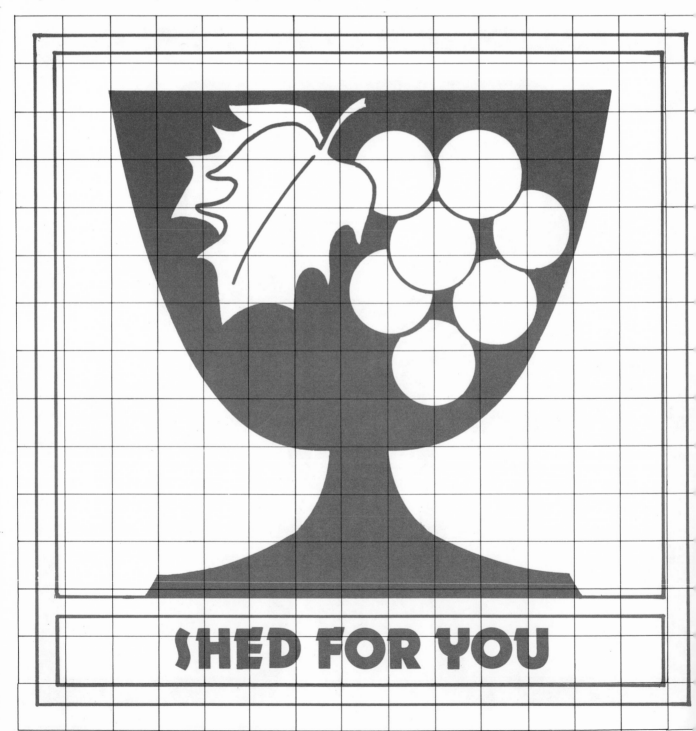

SHED FOR YOU

Christy, Chalice, and Bread

"This is the feast of victory for our God, for the Lamb who was slain has begun his reign. Alleluia. Alleluia." This hymn of praise sung at the eucharist tells of the great feast to come. Jesus offering bread and wine to his followers has become a picture of paradise and the messianic banquet, the marriage feast of the Lamb, of which the eucharist was an anticipation.

"Men will come from east and west, and from north and south, and sit at table in the kingdom of God" (Luke 13:29). "And again Jesus spoke to them in parables, saying, 'The kingdom of heaven may be compared to a king who gave a marriage feast for his son. . . . Go therefore to the thoroughfares, and invite to the marriage feast as many as you find' " (Matthew 22:1-2, 9). "They shall hunger no more, neither thirst any more. . . . For the Lamb in the midst of the throne will be their shepherd" (Revelation 7:16-17).

The intimacy of this supreme fellowship is told in a famous verse whose ending is often forgotten: "Behold . . . I will come in to him and eat with him and he with me" (Revelation 3:20).

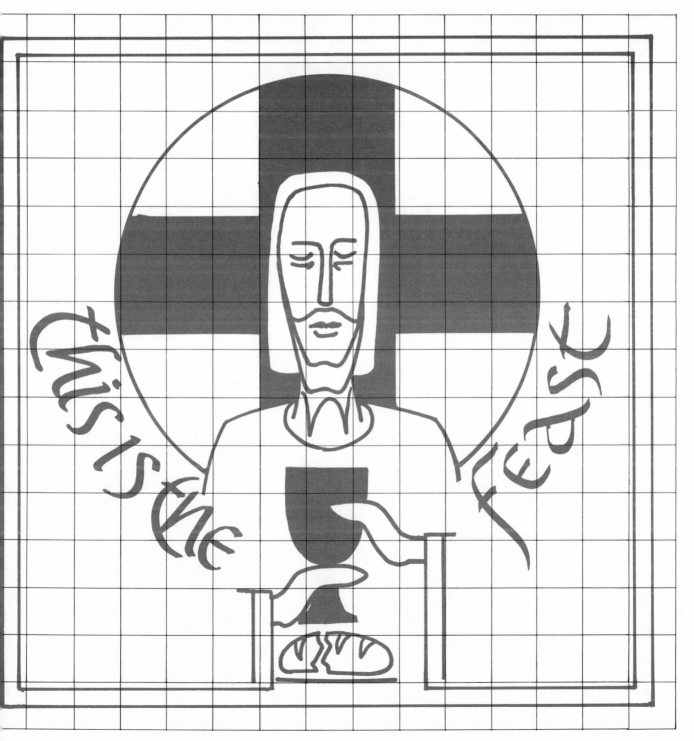

Cross

When his opponents in Corinth stressed a theology of power and glory, Paul spoke these powerful words: "The word of the cross is folly to those who are perishing, but to us who are being saved it is the power of God. . . . For Jews demand signs and Greeks seek wisdom, but we preach Christ crucified, a stumbling block to Jews and folly to Gentiles, but to those who are called, both Jews and Greeks, Christ the power of God and the wisdom of God" (1 Corinthians 1:18, 22-24). Again, dealing with his opponents in Galatia, he writes on this fundamental theme: "Far be it from me to glory except in the cross of our Lord Jesus Christ, by which the world has been crucified to me, and I to the world" (Galatians 6:14). And so the cross of Christ has continued to be the symbol most often used in Christian churches all through the ages.

The centrality of the cross is reflected in this symbol. The cross stands empty, reflecting the victory of the resurrection. But it stands there, reflecting the supreme sacrifice God made in his love for the entire world.

Cross and Hands

The lines in the symbol on page 58 may be seen as suggesting hands. Here they have been made explicit. The hands are upraised in a fashion often used in early Christian art to portray the triumphant church praying in supplication and thanksgiving. They may also remind us of Jesus' hands when he was crucified on the cross. At the same time, the openness of the hands suggests receptivity on the part of the faithful, who know the riches available to them because of Jesus' death and resurrection (Romans 3:23-25).

Combining the cross and hands here shows the object of our faith and thanksgiving united with the believer, who is called to bear the cross of Christ. "If any man would come after me, let him deny himself and take up his cross and follow me. For whoever would save his life will lose it; and whoever loses his life for my sake and the gospel's will save it" (Mark 8:34-35). Echoing this, St. Paul writes, "While we live we are always being given up to death for Jesus' sake, so that the life of Jesus may be manifested in our mortal flesh" (2 Corinthians 4:11).

Hands and Cross

Through the ages, artists have relied on gestures to convey meaning when speech seemed inadequate. In many ways we use gestures to augment our speech. And perhaps more than we realize, the actions and related gestures in worship are significant.

The symbol here reflects this reality. Key components of the liturgy are represented by the four pairs of hands. Beginning at the right, the hands assume the posture of prayer and supplication. Going clockwise, the upraised hands symbolize praise and thanksgiving. On the left, the open hands signify submission and receptivity to the gifts which God gives in grace. Finally, at the top, the hands are about to join together, symbolizing both reconciliation with God and reconciliation with one another in the exchange of the peace. They all are superimposed on the cross, the center of the gospel in worship. Petition and supplication, praise and thanksgiving, the receiving of gifts, and reconciliation—these are at the heart of our celebration of the Lord's victory.

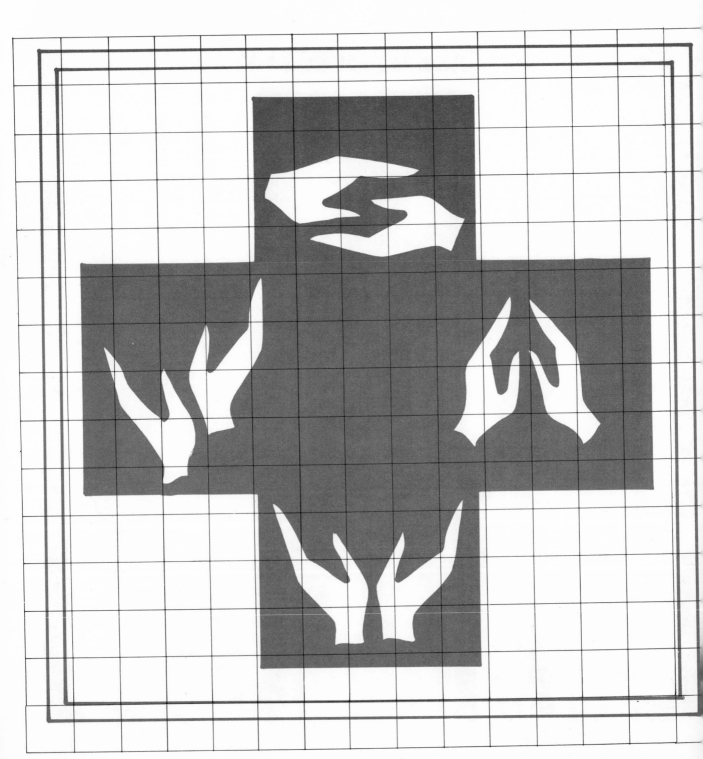

Hand

"The Lord bless you and keep you. The Lord make his face shine on you and be gracious to you. The Lord look upon you with favor and give you peace." Whatever the form of benediction at the end of the worship service, how wonderful to have a benediction pronounced over us as we prepare to leave, re-entering the world in which we live and work!

This symbol shows the Latin form of benediction, with two fingers closed. Originally this gesture signified not only benediction, but it also was used in scenes to represent Jesus' teaching of the disciples; it was the gesture of instruction. The Greek form (three fingers closed) and Latin form were interchangeable. Now the gesture universally seems to convey the peace and blessing of God.

We begin the congregational celebration with a benediction, "The grace of our Lord Jesus Christ, the love of God, and the communion of the Holy Spirit be with you all." And we end it in benediction.

"Peace I leave with you; my peace I give to you. Let not your hearts be troubled, neither let them be afraid" (John 14:27).

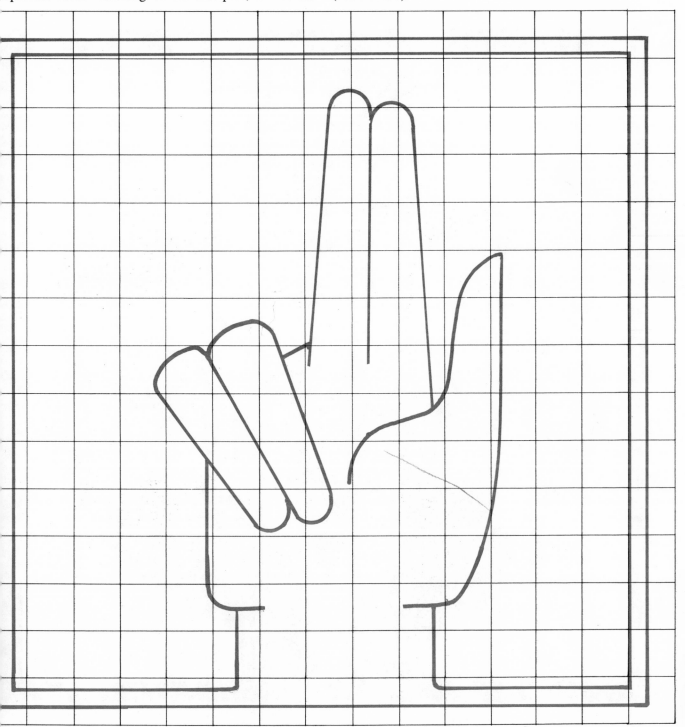

Dove and Hands

In Romans 8, Paul provides a profound description of the life in the Spirit, including the Spirit's role in prayer: "All who are led by the Spirit of God are sons of God. For you did not receive the spirit of slavery to fall back into fear, but you have received the spirit of sonship. When we cry, 'Abba! Father!' it is the Spirit himself bearing witness with our spirit that we are children of God, and if children, then heirs, heirs of God and fellow heirs with Christ" (Romans 8:14-17).

To think that the Spirit is helping us each time that we call upon God as his children is indeed amazing.

Paul's comments are a great comfort to all who have struggled with prayer: "Likewise the Spirit helps us in our weakness; for we do not know how to pray as we ought, but the Spirit himself intercedes for us with sighs too deep for words. . . . The Spirit intercedes for the saints according to the will of God" (Romans 8:26-27).

The powerful and profound role of the Spirit in prayer here is symbolized by the dove. The hands are lifted up in the traditional receptive posture of prayer.

Hands and Flames

Psalm 18 is titled "a psalm of David." David addressed this song to the Lord on the day when the Lord delivered him from the hand of all his enemies. As such, it is a classic example of prayer for deliverance and thanksgiving. "I love thee, O Lord, my strength . . . my God, my rock, in whom I take refuge . . . I call upon the Lord, who is worthy to be praised, and I am saved from my enemies. The cords of death encompassed me, the torrents of perdition assailed me; the cords of Sheol entangled me, the snares of death confronted me. In my distress I called upon the Lord. . . .

From his temple he heard my voice, and my cry to him reached his ears. . . . He reached me from on high. . . . He delivered me from my strong enemy" (Psalm 18:1-6, 16-17). Later in verse 28 he adds, "Yea, thou dost light my lamp; the Lord my God lightens my darkness."

God is often described as fire (Exodus 3:1-6, 13:22, 19:18; Ezekiel 1:26-28). Here God's speech also is fire. Thus in this symbol, God speaking to us in prayer is symbolized by flames which illuminate our darkness. God comes to us as God came to David, in response to our plea for deliverance.

Double Flame

Prayer is not a one-way street. If we approach God in prayer, we may be tested just as Jesus was tested as he prayed in the Garden of Gethsemane. Fire is a symbol of this testing, as in Psalm 66: "For thou, O God, hast tested us; thou hast tried us as silver is tried. Thou didst bring us into the net; thou didst lay affliction on our loins; thou didst let men ride over our heads; we went through fire and through water; yet thou hast brought us forth to a spacious place" (Psalm 66:10-12).

The same psalm reminds us how fire was used in worship. "I will come into thy house with burnt offerings. . . . I will offer to thee burnt offerings of fatlings, with the smoke of the sacrifice of rams" (Psalm 66:13-15). The psalmist closes with a doxology, "Truly God has listened; he has given heed to the voice of my prayer" (Psalm 66:19).

Fire symbolizes testing and worship which form part of prayer; fire symbolizes the presence of God at Pentecost: fire symbolizes zeal for the Lord in prayer. All these meanings and more might be seen in this design.

Here, as at Pentecost, fire brings life, not death.

Lyre

Because of his skill in playing the lyre, the shepherd boy, David, was appointed to King Saul's court. "And whenever the evil spirit from God was upon Saul, David took the lyre and played it with his hand; so Saul was refreshed, and was well, and the evil spirit departed from him" (1 Samuel 16:23). This is a marvelous example of the power of music. David's reputation as a music-maker grew as he grew older. Famous as king, he also became famous as the composer of psalms.

The psalter so closely linked with David has a number of references to the lyre or harp, including the one which is the closing doxology, Psalm 150. "Praise the Lord! Praise God in his sanctuary; praise him in his mighty firmament! Praise him for his mighty deeds; praise him with lute and harp! Praise him with timbrel and dance; praise him with strings and pipe! Praise him with sounding cymbals; praise him with loud clashing cymbals! Let everything that breathes praise the Lord! Praise the Lord!"

This exuberant picture of worship demonstrates how central music, including the harp and lyre, were in David's worship. And still are today in our worship.

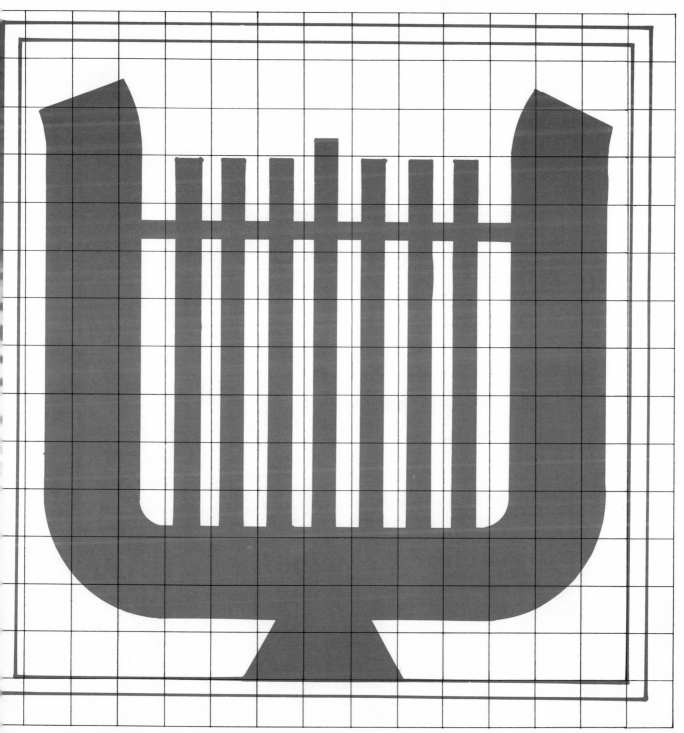

Angels with Trumpets

"Ascribe to the Lord, O heavenly beings, ascribe to the Lord glory and strength. Ascribe to the Lord the glory of his name; worship the Lord in holy array" (Psalm 29:1-2). This picture of heavenly beings in worship is confirmed by other biblical passages such as Hebrews 12:22: "You have come to Mount Zion and to the city of the living God, the heavenly Jerusalem, and to innumerable angels in festal gathering." In Revelation 7:11 we read, "All the angels stood round the throne . . . and they fell on their faces before the throne and worshiped God."

It must be a splendid sight to see throngs of angels worshiping God, and it also must be a splendid sound. There is also more than one hint that angels are great music-makers.

Revelation 4:10-11 and 5:9-13 similarly depict the singing by heavenly creatures. They play harps (Revelation 5:8). And they also blow trumpets, sometimes as heralds (Revelation 8—9), but no doubt in the making of music as well. What a glorious sound it must have been for the shepherds! What a glorious sound it will be!

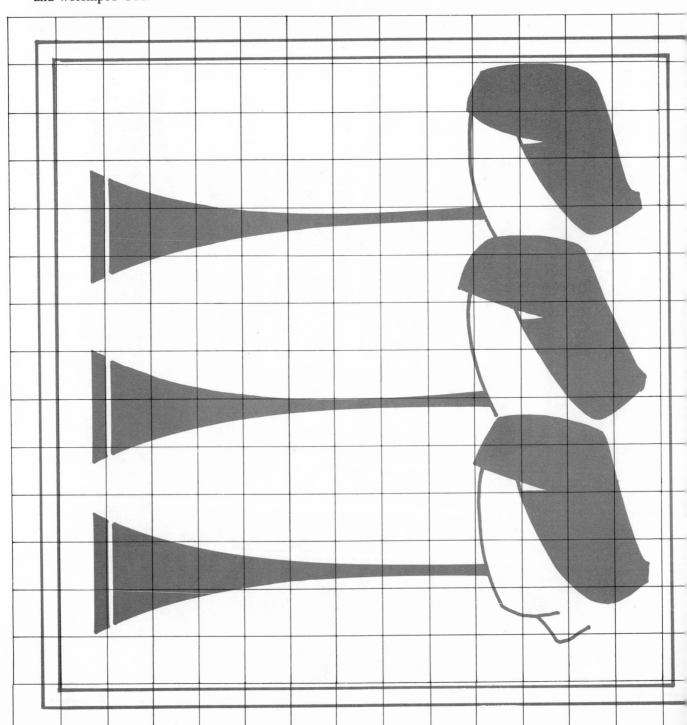

Plant, Cross, and Hearts

The baptized child can be compared to a shoot which the Lord has planted, just as God told Israel, ''Your people shall all be righteous; they shall possess the land for ever, the shoot of my planting, the work of my hands, that I might be glorified. The least one shall become a clan, and the smallest one a mighty nation; I am the Lord; in its time I will hasten it'' (Isaiah 60:21-22). The shoot does grow and at the age of responsibility, the child affirms for himself or herself what took place in Baptism. We call this the affirmation of Baptism or confirmation.

Paradoxically if the shoot grows to maturity, it will die. As Jesus said, ''He who finds his life will lose it, and he who loses his life for my sake will find it'' (Matthew 10:37-38).

The young person is called to a life centered in love for God and other people. This love is symbolized by the four hearts. ''This is my commandment, that you love one another as I have loved you. . . . You did not choose me but I chose you and appointed you that you should go and bear fruit. . . . This I command you, to love one another'' (John 15:12-17).

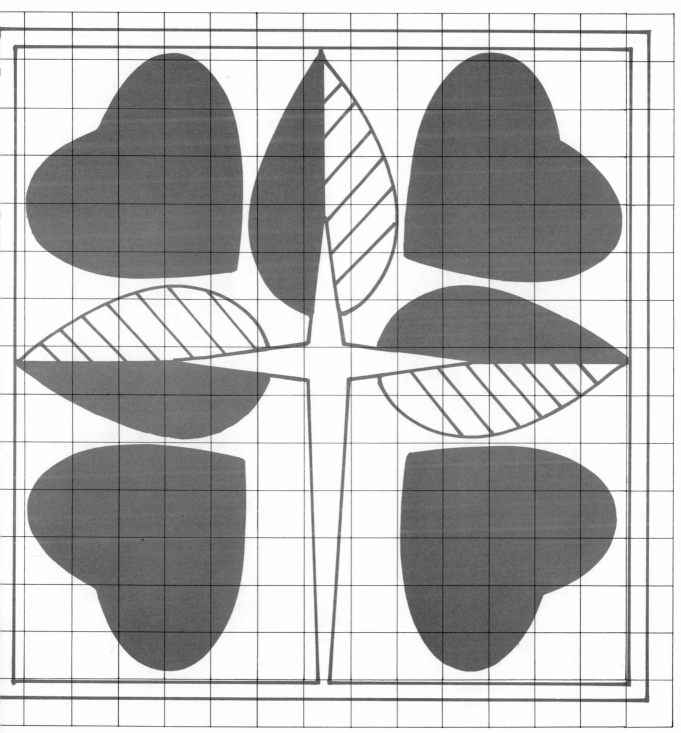

Dove, Cross, and Leaves

"And as for me, this is my covenant with them, says the Lord: my spirit which is upon you, and my words which I have put in your mouth, shall not depart out of your mouth, or out of the mouth of your children, or out of the mouth of your children's children, says the Lord, from this time forth and for evermore" (Isaiah 59:21). Affirmation of Baptism is the celebration of a process that begins with the bestowal of the Spirit in Jesus' baptism and in ours, symbolized here by the dove, and that continues in lifelong learning.

All are to grow, and all are to grow into Christ, represented here by the tree of life, cross, and leaves. Perhaps there is no better picture of this process of growth than Ephesians 4:13-16. We all are to "attain to the unity of the faith and of the knowledge of the Son of God, to mature manhood, to the measure of the stature of the fulness of Christ; so that we may no longer be children. . . . Rather . . . we are to grow up in every way into him who is the head, into Christ, from whom the whole body, joined and knit together by every joint with which it is supplied . . . makes bodily growth and upbuilds itself in love."

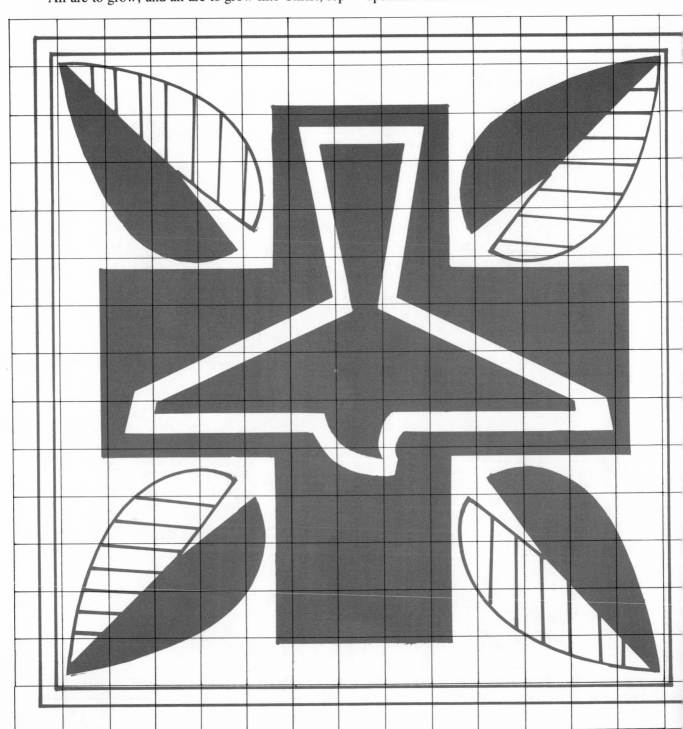

Cross/Shepherd's Crook

The cross has been refashioned in this symbol so that it is a shepherd's crook, a symbol of Jesus who is the Good Shepherd who lays down his life for the sheep (John 10:1-18). His sacrificial care stands in stark contrast to those passionate denunciations of Israel's chosen leaders in the past who were false shepherds (see Jeremiah 50; Ezekiel 34; Zechariah 11).

Despite such grave failings of past shepherds, the early church developed forms of ministries including pastors (which means "shepherds"), beginning with the 12 apostles. These early forms of ministry are beautifully described in Ephesians 4:7-12: "But grace was given to each of us according to the measure of Christ's gift. . . . And his gifts were that some should be apostles, some prophets, some evangelists, some pastors and teachers, to equip the saints for the work of ministry, for building up the body of Christ." This ministry of building up the body of Christ, the church, here is represented by the symbols of the Good Shepherd's office, the cross/crook and Word and Sacrament which are administered by the "shepherds" called to the flock.

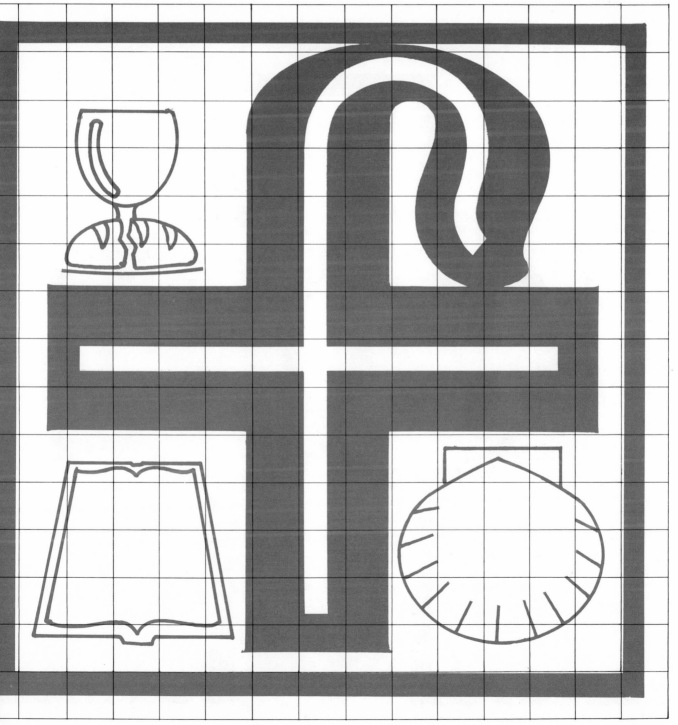

Cross and Rings

1 Corinthians 13 is a popular text for weddings, with its moving description of *agape,* the supreme love which we may know and share with one another. Actually, Paul wrote those words to everyone, married or not. The most extensive, specific passage on marriage in the New Testament is Ephesians 5:21-33. Certain aspects of that text may make some people feel uncomfortable. But its main point is a powerful definition of holy matrimony, elevating the relationship of man and woman to the highest possible level. Its conclusion is unexpected: '' 'For this reason a man shall leave his father and mother and be joined to his wife, and the two shall become one.' This is a great mystery, and I take it to mean Christ and the church.'' What high esteem and optimistic expectation for marriage, to compare it to Christ and his church!

Given the collapse of so many values, it is even more important to celebrate this relationship today. The symbol grounds on the cross of Christ the two intertwined rings symbolizing the new unity in one flesh. That cross and its ultimate sacrificial love remind us of the dimensions of our commitment to one another.

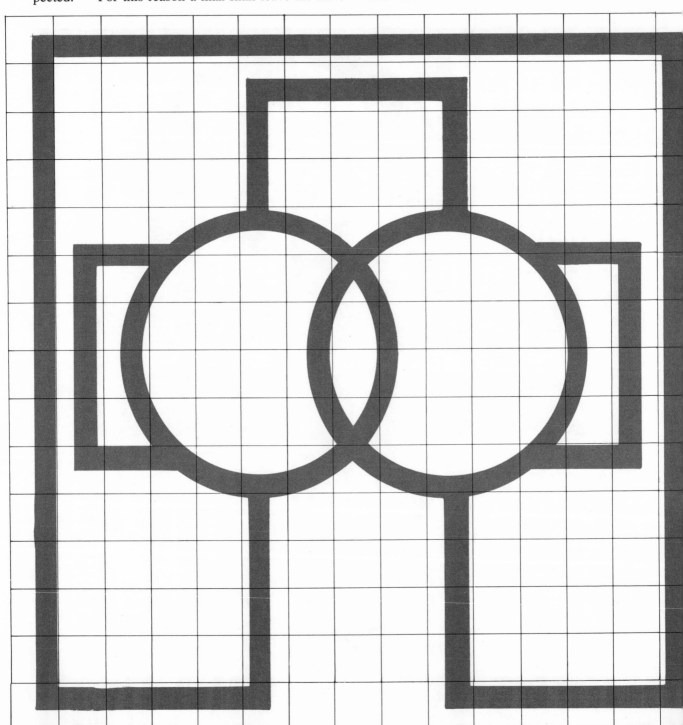

Hands, House, and Holy Family

House, household, family—in the New Testament such terms often were used interchangeably for the church. ''Now Moses was faithful in all God's *house* as a servant . . . but Christ was faithful over God's *house* as a son. And *we are his house* if we hold fast our confidence and pride in our hope'' (Hebrews 3:5-6). God, the builder of the house, is represented by the two hands stretched out in blessing over the house. The ''house of God'' or God's family is represented by the roof of a church.

The family is called a church several times in Paul's epistles. In Philemon 2, Paul sends greetings to Philemon and Apphia and Archippus and the church in their house, obviously referring to a family and any others who worshiped with them. Family, house, church—in Christ they all become one. And how often in Jesus' ministry a family at home became the scene for his greatest works, teachings, and miracles! His own family was the foundation for all this, as in the symbol, for there Jesus first became one with the whole human family in his quest to make it the family of God. He is the rock upon which we build our ''house.''

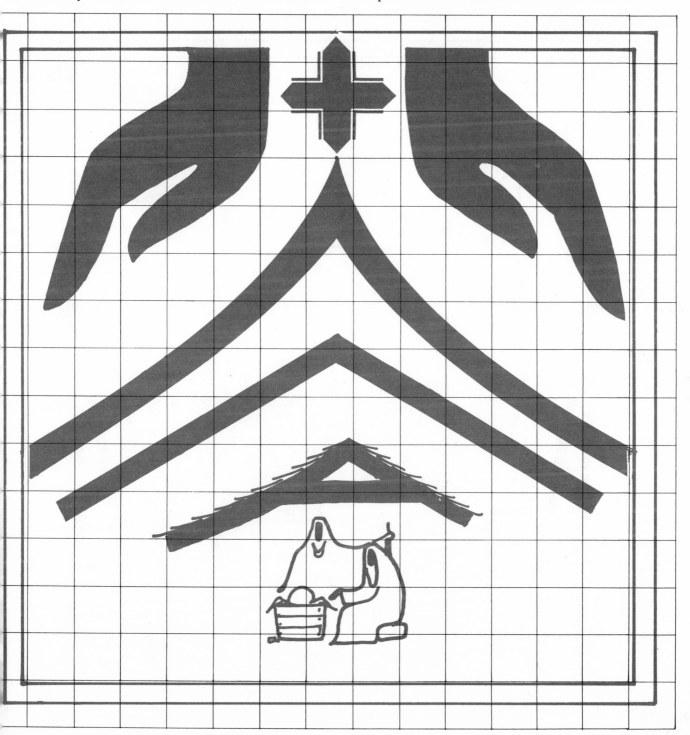

Figure with Pallet and Crutches

One of the first great tests of Jesus' authority came when he healed the paralytic who had been lowered down through the roof at Capernaum. Jesus said, " 'That you may know that the Son of man has authority on earth to forgive sin'—he said to the paralytic—'I say to you, rise, take up your pallet and go home.' And he rose, and immediately took up the pallet and went out before them all'' (Mark 2:10-12 and parallels). Jesus happily is always telling people to get up. In John 5:2-9, Jesus saw a man who had been ill 38 years lying at the pool of Bethzatha. The man did not know who Jesus was; he expected nothing. Again Jesus said, ''Rise, take up your pallet, and walk.'' The man was healed.

What was true of Jesus was also true of the apostles. Peter healed a man who had been paralyzed and bed-ridden for eight years (Acts 9:32-35). Even more miraculously, Peter raised a dead woman with a command to rise. ''Turning to the body he said, 'Tabitha, rise.' And she opened her eyes, and when she saw Peter she sat up'' (Acts 9:40). Thus the command to rise became not only a joyous symbol of healing but also of the resurrection.

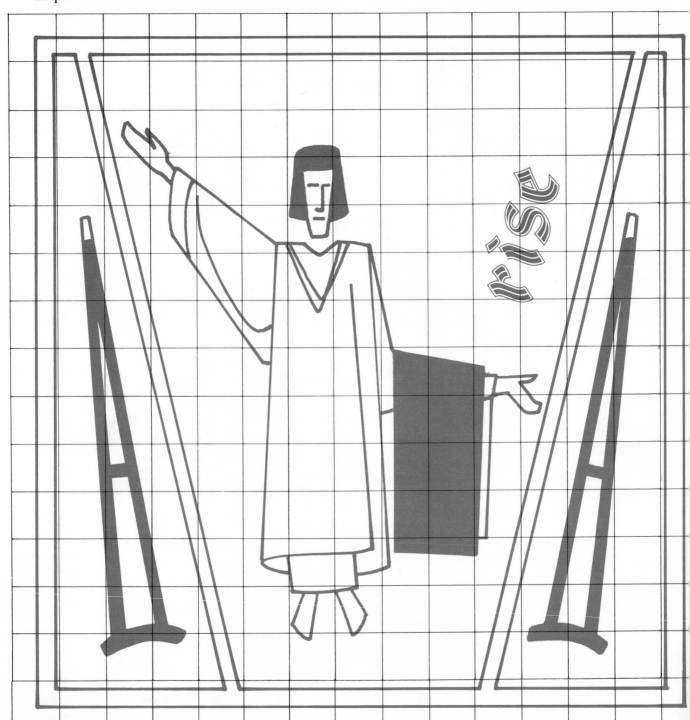

Butterfly

There is no reference to the butterfly in the Bible. In pagan art of the Greco-Roman tradition, the butterfly often represented the immortal soul. Christians in turn adopted it as a symbol of the resurrection, both of Christ and of the faithful. Today the butterfly is probably more popular than ever as such a symbol. There are good reasons for that.

The three stages that take place in a butterfly's life become symbols for a believer's journey. The larva suggests the lowly conditions of a human being on earth; the seemingly lifeless chrysalis represents the person's dead body in the grave; the butterfly is a symbol for the glorified body destined for eternal life. The Bible says that we shall be completely changed; our perishable, mortal nature will put on an imperishable, immortal nature (1 Corinthians 15:53). Both its ability to fly and its great beauty make the butterfly a symbol of the glory of the life to come.

What pagans had discovered in nature is made more profound in Jesus' death and resurrection and in the promise which belongs to all who believe in him. Jesus said, "I am the resurrection and the life" (John 11:25).

Cross and Wheat

"For as the earth brings forth its shoots, and as a garden causes what is sown in it to spring up, so the Lord will cause righteousness and praise to spring forth before all the nations" (Isaiah 61:11). Jesus takes such imagery and in a new way makes it a symbol of his and our death and resurrection. On the eve of his own death, Jesus used the sowing of wheat as an illustration. He said, "The hour has come for the Son of man to be glorified. Truly, truly, I say to you, unless a grain of wheat falls into the earth and dies, it remains alone; but if it dies, it bears much fruit" (John 12:23-24).

Interestingly, speaking to opponents in Corinth who denied the resurrection of the body, Paul used the same image: "But some one will ask, 'How are the dead raised? With what kind of body do they come?' You foolish man! What you sow does not come to life unless it dies. And what you sow is not the body which is to be, but a bare kernel, perhaps of wheat or of some other grain. . . . What is sown is perishable, what is raised is imperishable" (1 Corinthians 15:35-37, 42).

Such imagery inspired this design of stylized wheat combined with the cross.

Crocus

There is not a more cheery sight than crocuses blooming in late winter, while snow still is on the ground and the subsoil is frozen. They are a harbinger of the new life to come in spring after the dead of winter.

Isaiah makes reference to the crocus as just such a symbol of life to come. Apparently writing to the people of God after their land had been devastated and they had been carried off to exile, Isaiah paints a picture of a new age to come when Israel's fortune will be restored and even enhanced. "The wilderness and the dry land shall be glad, the desert shall rejoice and blossom; like the crocus it shall blossom abundantly, and rejoice with joy and singing. . . . Strengthen the weak hands, and make firm the feeble knees. Say to those who are of a fearful heart, 'Be strong, fear not!' . . . And the ransomed of the Lord shall return, and come to Zion with singing; everlasting joy shall be upon their heads; they shall obtain joy and gladness, and sorrow and sighing shall flee away'' (Isaiah 35:1-4, 10).

What a beautiful summary of our hope this text provides, with the crocus symbolizing the new life to come!

Signposts and Cross

On Pentecost, "there were dwelling in Jerusalem Jews, devout men from every nation . . . and they were bewildered, because each one heard them (the disciples) speaking in his own language. And they were amazed and wondered, saying, 'Are not all these who are speaking Galileans? And how is it that we hear, each of us in his own native language? Parthians and Medes and Elamites and residents of Mesopotamia, Judea and Cappadocia, Pontus and Asia, Phrygia and Pamphylia, Egypt and the parts of Libya belonging to Cyrene, and visitors from Rome, both Jews and proselytes, Cretans and Arabians, we hear them telling in our own tongues the mighty works of God' " (Acts 2:5-13).

The long list of place names showed that the gospel was no longer to be confined to one race or holy place. What began then is still going on, as the gospel spreads to more and more nations. The symbol shows a cluster of signposts. With a viewpoint from North America, the continents of Asia, Africa, Europe, and South America are represented. The cross in the center is the gospel and at the same time the symbol of the suffering which the church experiences in many areas.

Flames, Crosses, and Globe

In the history of salvation, the Israelites slowly came to realize that God had a plan for all peoples, not only for the physical descendants of Abraham. A good example of this growing realization is found in Isaiah 49:6, where the Lord says, ''It is too light a thing that you should be my servant to raise up the tribes of Jacob and to restore the preserved of Israel; I will give you as a light to the nations, that my salvation may reach to the end of the earth.''

It is significant to note that Paul quotes this as confirmation of the mission of the early Christian church to the Gentile nations in Acts 13:47. The servant whom God raised up was Jesus, who boldly claimed for himself that he was the Light of the world as predicted in Isaiah. In the design, the flaming cross stands at the center, representing Jesus, the Light of the world. The four arms of flames reflect the empowerment of the Holy Spirit at Pentecost, now spreading out to the four corners of the globe, symbolized by the four crosses. The circle reminds us that we are one in Christ and also in our calling, wherever we live in God's world. All of us are the fruit of mission; all of us are the doers of mission.

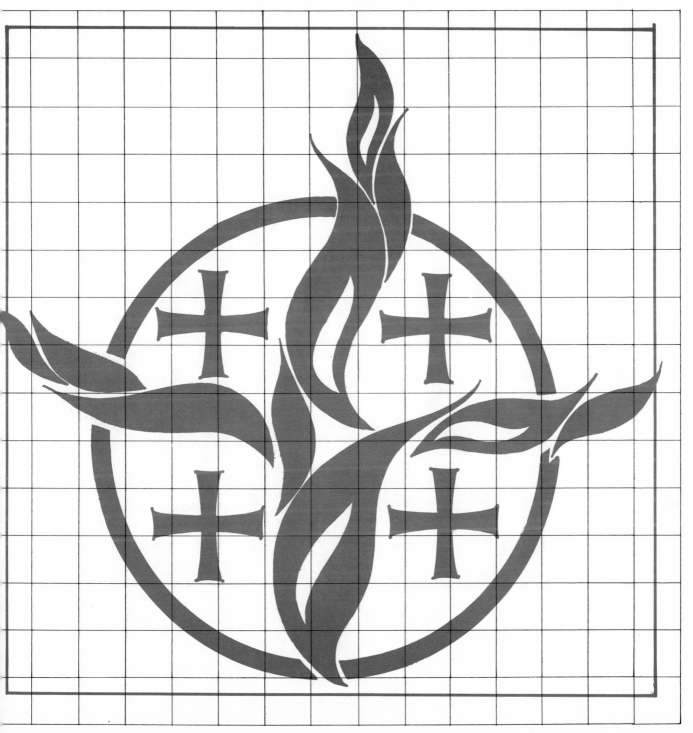

Eight-pointed Star

Moved by the Spirit of God, Balaam, the foreign priest-diviner pronounced an oracle: ''A star shall come forth out of Jacob, and a scepter shall rise out of Israel'' (Numbers 24:17). The star was the future King David, but the early church applied it to David's descendant, Jesus. In Revelation 22:16, Jesus is quoted as saying, ''I am the root and the offspring of David, the bright morning star.'' That morning star here is symbolized by an eight-pointed star, a symbol of the resurrection and regeneration.

The morning star, like light, also can represent the growth of faith in people's hearts. Thus, the author of 2 Peter refers to the Lord's transfiguration and says, ''You will do well to pay attention to this as to a lamp shining in a dark place, until the day dawns and the morning star rises in your hearts'' (2 Peter 1:19). The spreading of the light of the morning star who is Christ here is portrayed by a geometric star which can be endlessly expanded, beginning from the center's double cross, always pointing outward stage by stage to the unfinished task, until that day when the Morning Star rises once for all.

Globe and Hands

Psalm 115:14-16 includes this benediction, "May the Lord give you increase, you and your children! May you be blessed by the Lord, who made heaven and earth! The heavens are the Lord's heavens, but the earth he has given to the sons of men." It is the Lord who gives, and one of the gifts he gives is the earth which he has made. As Psalm 67:6 says, "The earth has yielded its increase; God, our God has blessed us." That is the foundation of stewardship as illustrated here, with the hands of God giving the earth to us, represented by the hands below.

But what we receive as a gift, we also offer back to God in thanksgiving. As the liturgy of Holy Communion expresses it, "Blessed are you, O Lord our God, maker of all things. Through your goodness you have blessed us with these gifts. With them we offer ourselves to your service and dedicate our lives to the care and redemption of all that you have made, for the sake of him who gave himself for us, Jesus Christ our Lord. Amen." In thanksgiving, we offer back to God what God first gave us, and we accept responsibility for its well-being. That is stewardship.

Orders of Creation

Stewardship encompasses all of creation, all of life. Everything God has made is to praise and serve him. Understood this way, stewardship is not a grudging miserly response but one of joy and celebration of the mighty promises of God. Nor is it confined to humans. "Mountains and all hills, fruit trees and all cedars! Beasts and all cattle, creeping things and flying birds! Kings of the earth and all peoples, princes and all rulers of the earth! Young men and maidens together, old men and children! Let·them praise the name of the Lord, for his name alone is exalted; his glory is above earth and heaven. . . . Praise the Lord!" (Psalm 148:9-14).

The design reflects this all-encompassing aspect of stewardship. The cross, the source of our salvation, stands in the center. Around it are the classic orders of creation: home, church, vocation, and the state. We are called by God to live as good stewards in all four of those areas of life.

Surrounding these four places are the gifts of God: the presence of God represented by the dove, the Word, and the sacraments (the waterdrop as a symbol for Baptism, bread and wine as symbols for the eucharist).

Time, Talents, Treasure

In our worship services, after the gifts have been brought forward, an offertory prayer is said which expresses the essence of stewardship: "Merciful Father, we offer with joy and thanksgiving what you have first given us—our selves, our time, and our possessions, signs of your gracious love. Receive them for the sake of him who offered himself for us, Jesus Christ our Lord." Here time, talents, and treasure are understood as gifts from God which we offer back to God. The rainbow is a sign of God's love for creation. Time is represented by the hourglass; talents by the spade (labor), pencil (learning and white collar work), ladle (the home), and clarinet (music, arts, leisure); and treasure by the chest.

Psalm 103 reflects the same pattern of stewardship—God's gifts to us and our response: "Bless the Lord, O my soul, and all that is within me, bless his holy name! Bless the Lord, O my soul, and forget not all his benefits, who forgives all your iniquity . . . who satisfies you with good as long as you live. . . . Bless the Lord, all his works, in all places of his dominion. Bless the Lord, O my soul!" (Psalm 103:1-5, 22).

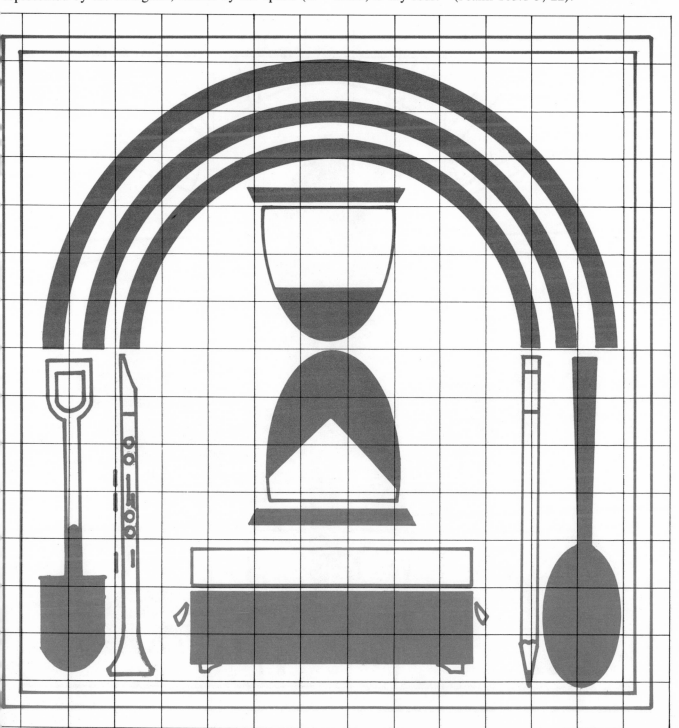

Plant and Sun

In various biblical texts, God is compared to a gardener or farmer. For example, Psalm 65:9-12 says of God, ''Thou visitest the earth and waterest it, thou greatly enrichest it; the river of God is full of water. . . . Thou crownest the year with thy bounty . . . the valleys deck themselves with grain.'' Paul takes such imagery and applies it to his own calling. Referring to his fellow worker Apollos and himself, he writes, ''I planted, Apollos watered, but God gave the growth. So neither he who plants nor he who waters is anything, but only God who gives the growth'' (1 Corinthians 3:6-7).

That same image can be applied to our own calling as God's stewards of life. As the familar hymn puts it, ''We plow the fields and scatter the good seed on the land, but it is fed and watered by God's almighty hand. . . . No gifts have we to offer for all your love imparts, but what you most would treasure—our humble, thankful hearts. All good gifts around us are sent from heav'n above. Then thank the Lord, oh, thank the Lord for all his love.'' Here God is represented by the sun, giving life to all. We are called to care for his garden until the harvest.

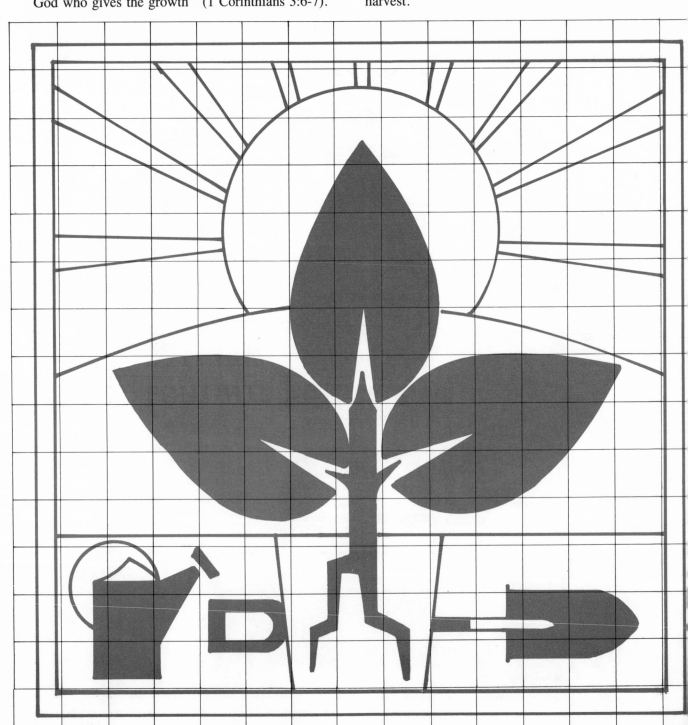

Dove and Water

"In the beginning God created the heavens and the earth. The earth was without form and void, and darkness was upon the face of the deep; and the Spirit of God was moving over the face of the waters" (Genesis 1:1-2). This great moment in creation is represented here by a sphere divided into earth and heaven. The earthly realm is the primeval waters, believed to be a watery chaos, represented by waves. The Spirit of God moving over the face of the waters is represented by the dove, the form in which the Spirit appeared at Jesus' baptism. From chaos and formlessness God created an orderly world into which human beings were placed and assigned a pre-eminent position.

John 1:2-3 says of Jesus: "He was in the beginning with God; all things were made through him and without him was not anything made that was made." The Father, Son, and Spirit—the three in one—created the earth, continued to care for it and its inhabitants after the fall, and prepared its redemption. This symbol particularly points out the work of the Spirit in creation. Romans 8 speaks of the Spirit's role in redemption, in the freeing of the created world from its bondage to decay.

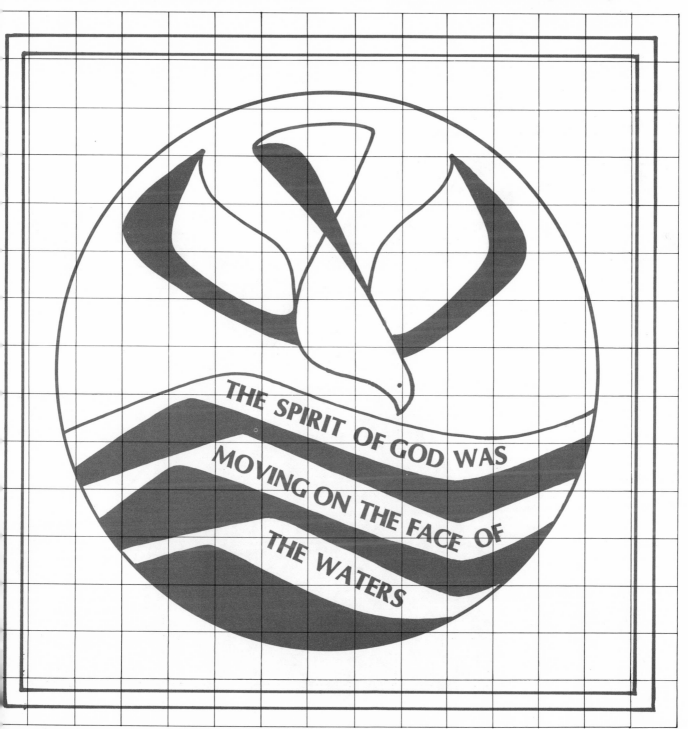

Rainbow and People

In the first centuries after Christ, one of the earliest and most popular subjects in Christian art was the story of Noah. The ark was understood as the church, and the whole story was prized as a symbol of deliverance. The rainbow which God created at the end of the flood is the universal sign of that deliverance. "This is the sign of the covenant which I make between me and you and every living creature that is with you, for all future generations. . . . When the bow is in the clouds, I will look upon it and remember the everlasting covenant between God and every living creature" (Genesis 9:12-

16). Thus God spoke to Noah about his promise never again to destroy life with a flood.

In the only other references to the rainbow in the Bible (Ezekiel 1:27-28 and Revelation 4:3; 10:1) that sign of God's loving and faithful providence becomes a symbol for God himself. When describing God upon the heavenly throne in Ezekiel 1, Ezekiel says, "There was brightness round about him. Like the appearance of the bow that is in the cloud on the day of rain, so was the appearance of the brightness round about."

What a magnificent sight that must be!

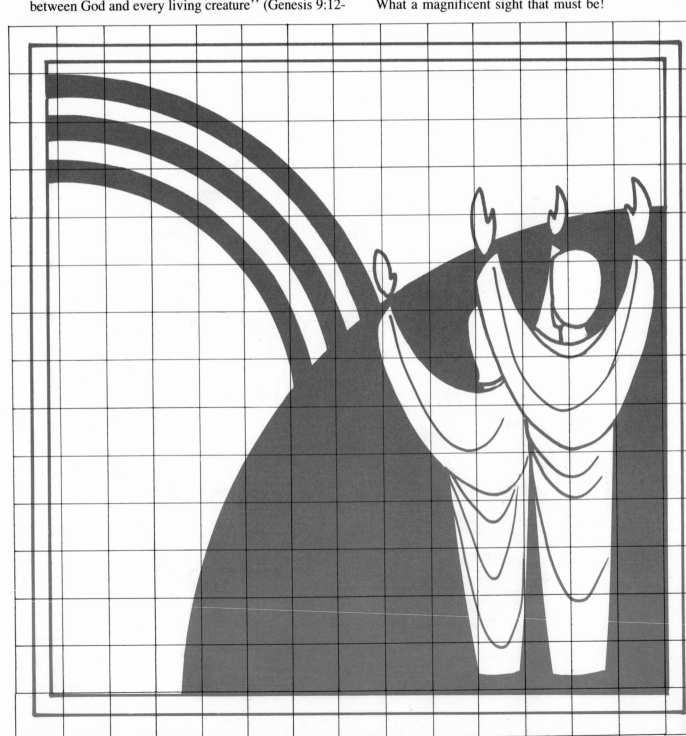

Eye of God

One of the most common symbols of God the creator is the eye of God, sometimes set in a triangle, sometimes with rays proceeding from it. Here the eye of God is seen as a swirling vortex, symbolic of God's irresistible power and omnipotence. Sometimes the eye of God is thought to be a symbol of his judgment, a negative and dreadful sign. But originally the eye of God was understood in a kindly and caring sense. That goodliness is underlined here by combining the eye with the closing words from the account of the creation of the world in Genesis 1:1—2:3. At the end of each day of creation,

it is recorded, "And God saw that it was good." But after God had completed everything, this is given added emphasis: "And God saw everything that he had made, and behold, *it was very good*" (Genesis 1:31). This marvelous joy of God in his own creation, in what he saw, is what the eye of God symbolizes.

Despite the later cataclysmic fall of creation, God persists in his joy in creation and provides for its redemption and for its re-creation. God is creating a new heaven and a new earth (Revelation 21:1). And God sees that it is and will be good!

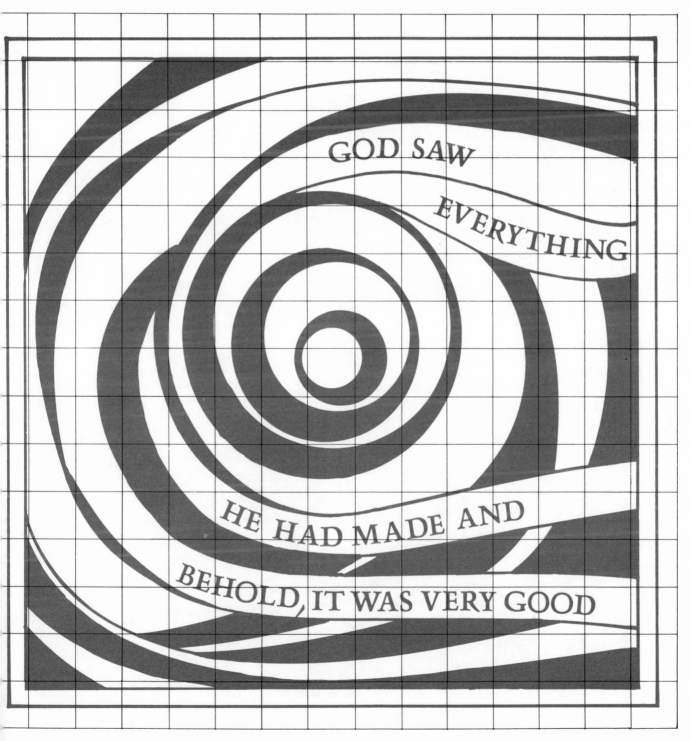

GOD SAW EVERYTHING HE HAD MADE AND BEHOLD, IT WAS VERY GOOD

Dove with Olive Branch

The dove and olive branch pictured here have become a universal symbol of peace in the world. They recall the story of the flood, where the dove bringing back the olive branch to the ark became a symbol of deliverance and new life safe from the flood (Genesis 3:6-12).

Several eloquent biblical passages reflect the yearning for this peace, not only as individuals but also for the nations. For example, Psalm 85 is a moving prayer for deliverance from national adversity: ''Let me hear what God the Lord will speak, for he will speak peace to his people. . . . Surely his salvation is at hand for those who fear him. . . . Steadfast love and faithfulness will meet; righteousness and peace will kiss each other'' (Psalm 85:8-10). Paul writes, ''First of all, then, I urge that supplications, prayers, intercessions, and thanksgivings be made for all men, for kings and all who are in high positions, that we may lead a quiet and peaceable life'' (1 Timothy 2:1-2). Isaiah foresaw that a child called Prince of Peace would establish peace forever (Isaiah 9:6-7). And so the angels sang over Bethlehem, ''Glory to God in the highest, and on earth peace'' (Luke 2:14).

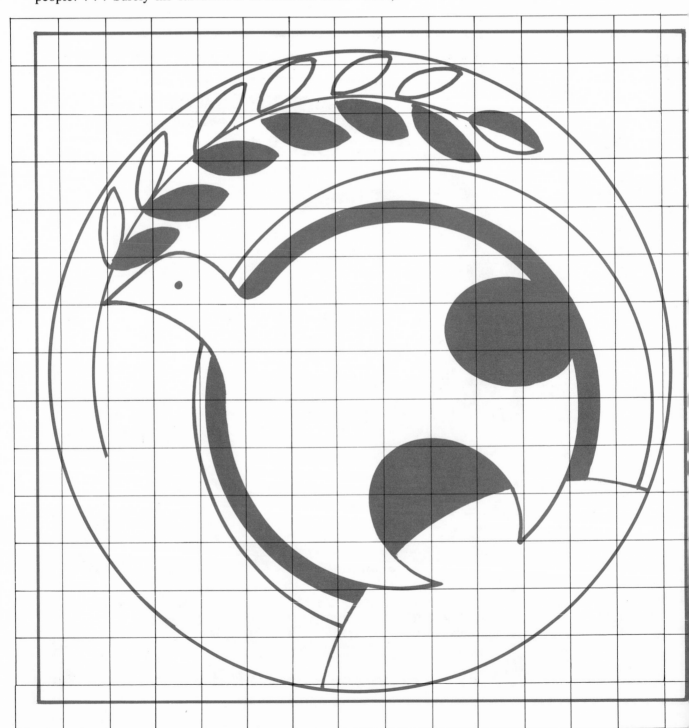

Hands with Bowl

The many stories of Jesus eating with various people tell us how he could enjoy eating. His critics accused him of overdoing it, of being a glutton and a drunkard, a friend of tax collectors and sinners (Luke 7:34). What an irony, since Jesus himself repeatedly reflected a passionate concern for the hungry and downtrodden! No example makes this more clear than the great judgment scene of Matthew 25:31-46, when Jesus describes the welcome in heaven that will be given those who fed the hungry, gave drink to the thirsty, clothed the naked, and so forth, while condemning those who did not do these things. He makes an absolute identity between himself and those who suffer. "Truly, I say to you, as you did it to one of the least of these my brethren, you did it to me" (Matthew 25:40).

The same concern is expressed elsewhere. "He said to them, 'Whoever receives this child in my name receives me, and whoever receives me receives him who sent me'" (Luke 9:47-48). "Whoever gives to one of these little ones even a cup of cold water because he is a disciple, truly, I say to you, he shall not lose his reward" (Matthew 10:42).

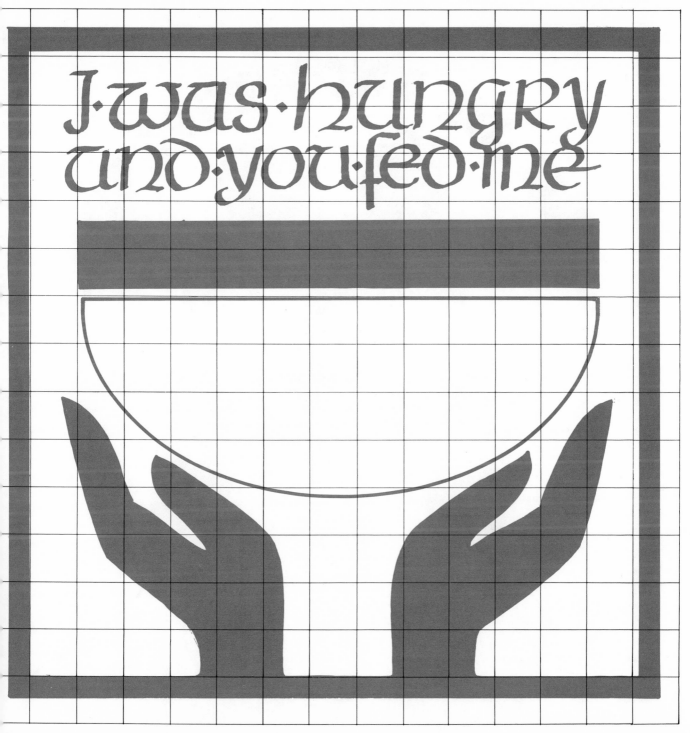

Loaves and Fish

Body and soul are inseparable in Christian faith. This is demonstrated ultimately by the resurrection of Jesus. It also is reflected in the numerous instances of healing and caring in Jesus' ministry. Jesus' concern for physical as well as spiritual well-being is shown in Mark 8:1-3, the feeding of the 4000. Jesus told his disciples that he had compassion on the crowd, because they had nothing to eat. He knew many of them had a long way to travel home. So from seven loaves, he fed them all, ''and they ate, and were satisfied'' (Mark 8:8).

That same concern was shown in the feeding of the 5000 (Mark 6:34-44). It is the feeding of the 5000 which is suggested here, showing the five loaves and two fish which Jesus used to feed the crowd. This incident, reported in all four gospels, spawned a popular symbol in early Christian art; it signified not only the satisfaction of physical hunger now, but also the promise of the feast to come, the messianic banquet in paradise. This reflects Jesus' own promise: ''Men will come from east and west, and from north and south, and sit at table in the kingdom of God'' (Luke 13:29).

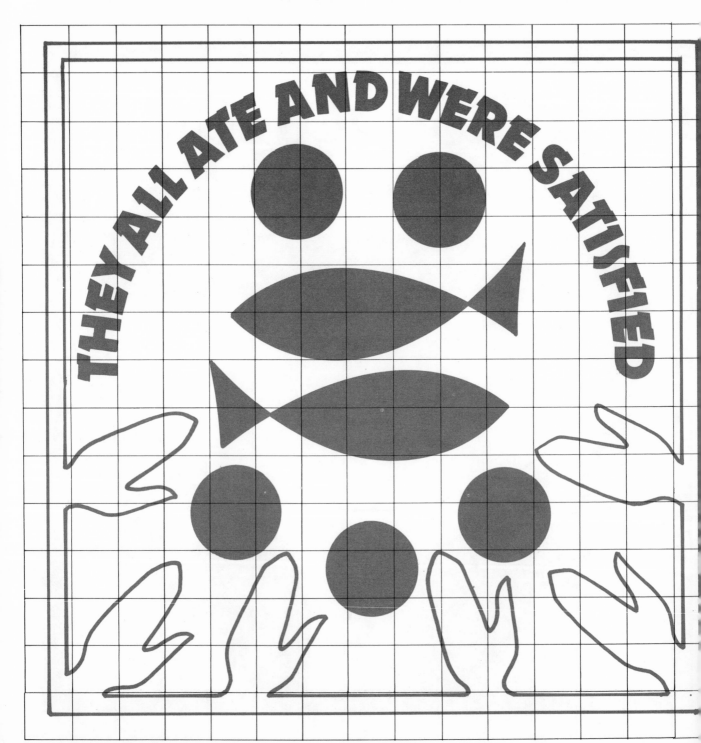

Lion and Lamb

There is perhaps no more brilliant or pointed discussion of both the present agony of the created world and of its hope than Paul's words in Romans 8:18-25: ''For the creation waits with eager longing for the revealing of the sons of God . . . because the creation itself will be set free from its bondage to decay and obtain the glorious liberty of the children of God.''

The hope of what is to come for the entire world is expressed eloquently in Isaiah's picture of the ''peaceable kingdom'': ''Behold, I create new heavens and a new earth. . . . No more shall be heard in it the sound of weeping and the cry of distress. . . . The wolf and the lamb shall feed together, the lion shall eat straw like the ox; and dust shall be the serpent's food. They shall not hurt or destroy in all my holy mountain, says the Lord'' (Isaiah 65:17-25). This vision, which has captured the imagination of artists through the ages, also is found in Isaiah 11:1-9: ''The leopard shall lie down with the kid, and the calf and the lion and the fatling together, and a little child shall lead them.'' Such texts convey the hope of a day when a new paradise will surpass even the Garden of Eden in its joy and glory.

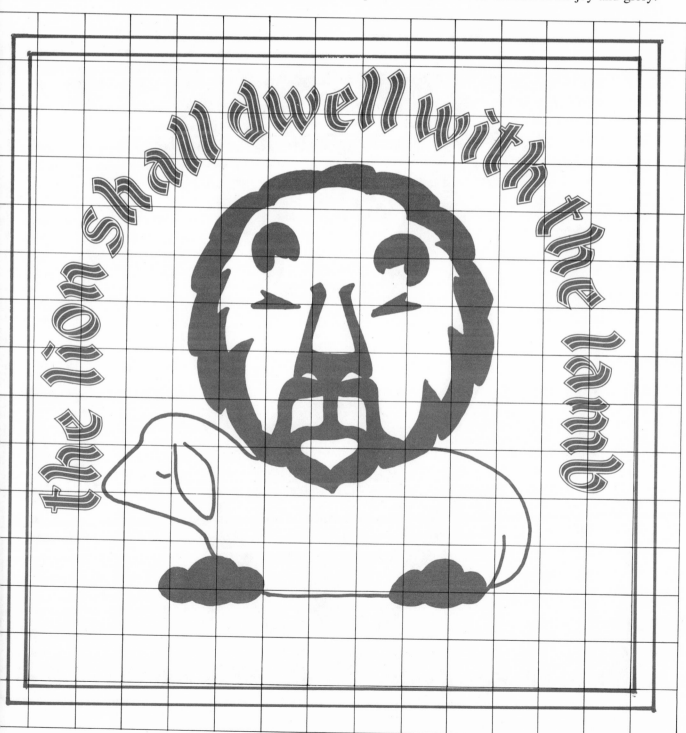

Eye of God, Dove, and Cross

". . . one nation, indivisible, with liberty and justice for all." These familiar words from our pledge of allegiance echo familiar words in the Bible, especially in the intense messages of prophets such as Isaiah: "The Spirit of the Lord God is upon me, because the Lord has anointed me to bring good tidings to the afflicted . . . to proclaim liberty to the captives, and the opening of the prison to those who are bound, to proclaim the year of the Lord's favor" (Isaiah 61:1-2). The astonishing thing, perhaps, is that Jesus used this very text as the keynote in opening his years of public ministry (Luke 4:14-30). He had been baptized, had been tested by the devil in the wilderness; then he returned to his hometown of Nazareth. There in the opening speech of his public ministry, he read the text from Isaiah, closed the book, and said to them, "Today this scripture has been fulfilled in your hearing" (Luke 4:21). That passion for liberty and justice led Jesus to a cruel death.

In this symbol the eye of God symbolizes God's concern for the world; the dove, God's guiding Spirit; the cross, the means God used to defeat evil and restore the world to God.

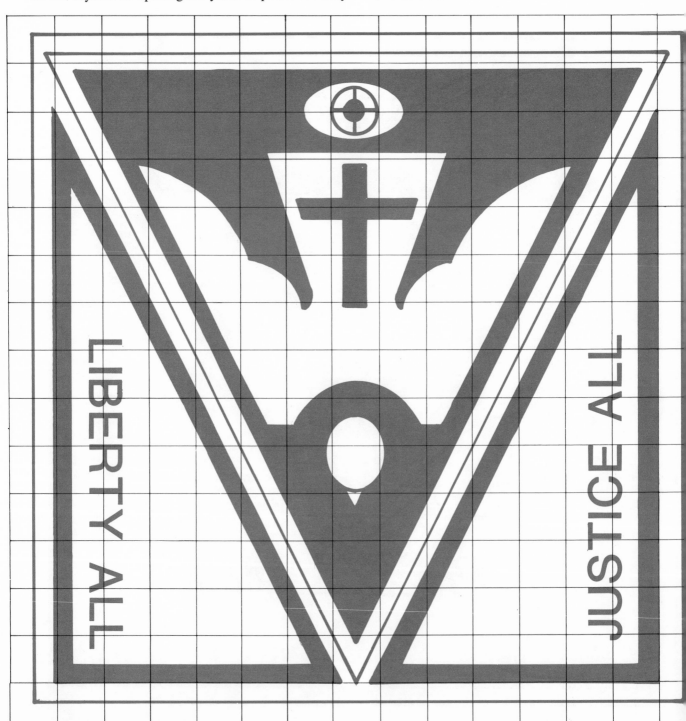

Lamb and Crook

While the people of Israel and Judah suffered under the rule of corrupt officials, there arose the vision of a future day when a Good Shepherd would come who would care for his flock. Isaiah and Micah had this hope: "Behold the Lord God comes with might. . . . Behold, he will feed his flock like a shepherd, he will gather the lambs in his arms" (Isaiah 40:10-11). "But you, O Bethlehem Ephrathah . . . from you shall come forth for me one who is to be ruler in Israel. . . . And he shall stand and feed his flock in the strength of the Lord" (Micah 5:2-4).

For Christians, this great hope was realized in Jesus, who claimed to be that Good Shepherd (John 10:7-18). Jesus in turn expects that his followers will care for the flock. In John 21:1-19, Jesus three times told Peter to feed and tend his sheep. And what Jesus told Peter, James applied to all: "If a brother or sister is ill-clad and in lack of daily food, and one of you says to them, 'Go in peace, be warmed and filled,' without giving them the things needed for the body, what does it profit?" (James 2:14-16).

Jesus says to the church, "Feed my sheep!"

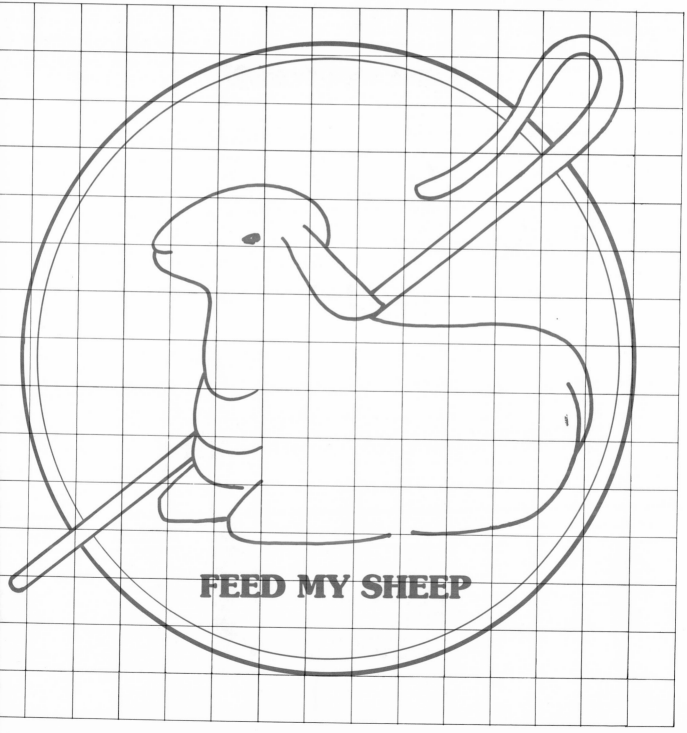

FEED MY SHEEP

Cross and Hands

During his ministry, Jesus often talked about his coming suffering and death. In stark language, Jesus told his disciples, "He who loves father or mother more than me is not worthy of me, and he who loves son or daughter more than me is not worthy of me, and he who does not take his cross and follow me is not worthy of me" (Matthew 10:37-38).

In a great paradox, Paul asserts that this is indeed what happens to Christians. "We were buried therefore with him by Baptism into death. . . . We know that our old self was crucified with him so that the sinful body might be destroyed, and we might no longer be enslaved to sin. . . . We have died with Christ. . . . So you also must consider yourselves dead to sin and alive to God in Christ Jesus" (Romans 6:4-11). Our model is Jesus himself: "Have this mind among yourselves, which you have in Christ Jesus, who . . . emptied himself, taking the form of a servant. . . . And being found in human form, he humbled himself and became obedient unto death, even death on a cross" (Philippians 2:5-8). We are to be willing to lose our lives, and in losing them for Christ's sake, we find them.

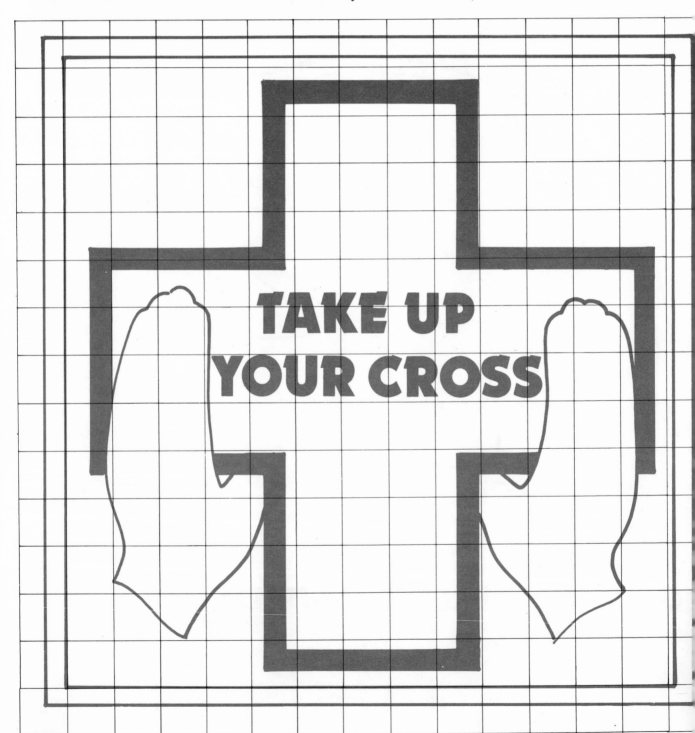

TAKE UP
YOUR CROSS

Foot

"Follow me" may be the most common and radical command Jesus addressed to his followers; it occurs in all four gospels. We first hear this command at the beginning of Jesus' public ministry. "He found Philip and said to him, 'Follow me' " (John 1:43). Later on Jesus saw Matthew sitting at the tax office, and he issued the same call: "Follow me." The same command was given when Jesus as the resurrected Lord appeared to his disciples. Twice he told Peter, "Follow me!" (John 21:19,22).

For some following Jesus meant giving up all they had in order to begin a whole new vocation as the apostles did. And for all Christians, following means sharing in a new world with Christ. Speaking of himself as the Good Shepherd, Jesus says, "The sheep hear his voice, and he calls his own sheep by name and leads them out. When he has brought out all his own, he goes before them, and the sheep follow him, for they know his voice" (John 10:3-4). Thus, the command to follow, which seems so threatening, becomes the promise of life. We go where the Good Shepherd leads.

Rocks, Plant, and Sun

"A sower went out to sow. And as he sowed, some seeds fell along the path. . . . Other seeds fell on rocky ground. . . . Other seeds fell upon thorns. . . . Other seeds fell on good soil. . . . As for what was sown on good soil, this is he who hears the word and understands it; he indeed bears fruit, and yields, in one case a hundredfold, in another sixty, and in another thirty" (Matthew 13:1-23).

The Christian life is often described as a plant. For example, Ephesians 3:14-19 includes the prayer that we may be "rooted and grounded in love" and "may be filled with all the fulness of God." Isaiah 55:10-11 speaks of the rain and snow watering the earth, so the plants grow, giving seed to the sower and bread to the eater. "So shall my word be that goes forth from my mouth, it shall not return empty." God gives growth.

Sunlight can be a symbol for God: "The Lord will be your everlasting light. . . . Your people shall all be righteous . . . the shoot of my planting, the work of my hands, that I might be glorified" (Isaiah 60:19-21). With God's Word as the source of life, there is growth for the Christian.

Ship on Sea of Galilee

God's people are called to leave the familiar and comfortable to follow where God leads. "Now the Lord said to Abram, 'Go forth from your country and your kindred and your father's house to the land that I will show you. . . . So Abram went, as the Lord had told him'' (Genesis 12:1, 4). Speaking of Moses, Hebrews 11:26-27 says, "By faith he left Egypt, not being afraid of the anger of the king; for he endured as seeing him who is invisible." And so it was with the apostles. "And Jesus said to them, 'Follow me.' " (Mark 1:17). Later on Peter recalled that they had left their homes to follow Jesus.

Jesus answered, "There is no man who has left house or wife or brothers or parents or children, for the sake of the kingdom of God, who will not receive manifold more in this time, and in the age to come eternal life'' (Luke 18:28-30). Remembering such promises, encouraging discouraged and persecuted believers, Hebrews 13:12-14 makes this appeal: "Jesus also suffered outside the gate in order to sanctify the people through his own blood. Therefore let us go forth to him outside the camp, bearing abuse for him. For here we have no lasting city, but we seek the city which is to come."

THEY LEFT THEIR NETS
AND FOLLOWED HIM

Index

Alpha/Omega, Tablets, and Scroll, 16
Angel, 10
Angel, Trumpets, and Cemetery, 36
Angels with Trumpets, 66
Bells, 7
Bethlehem and Holly, 12
Bible, 48
Bible and Symbols of Four Seasons, 49
Bible, Chalice, and Water, 46
Bible, Dove, Water, Word, Chalice, and Bread, 47
Butterfly, 73
Candles, 8
Candles and Dove, 11
Chalice and Grapes, 56
Chalice and Wafer, 54
Chalice, Bread, and Bible, 55
Christ, Chalice, and Bread, 57
Crocus, 75
Cross, 58
Cross and Crown of Thorns, 18
Cross and Hands, 59, 92
Cross and Rings, 70
Cross and Wheat, 74
Cross/Shepherd's Crook, 69
Crown, Donkey, and Thorns, 20
Crowns, Gifts, and Star/Cross, 15
Double Flame, 64
Dove, 26
Dove and Flames, 30
Dove and Hands, 62
Dove and Water, 51, 83
Dove, Cross, and Leaves, 68
Dove with Olive Branch, 86
Drop of Water and Dove, 50
Easter Lilies, 23
Eight-pointed Star, 78
Enthroned Christ, 39
Eye of God, 85
Eye of God, Dove, and Cross, 90
Figure with Pallet and Crutches, 72
Five Greek Crosses, 17
Flames, 6
Flames and World, 44
Flames, Crosses, and Globe, 77

Foot, 93
Fortress, 35
Fruits of the Spirit, 28
Globe and Hands, 79
Hand, 61
Hands and Cross, 60
Hands and Flames, 63
Hand, Flames, and Sun, 27
Hands, House, and Holy Family, 71
Hands with Bowl, 87
Heart and Circles, 33
Hourglass and Alpha/Omega, 41
Lamb and Angels, 42
Lamb and Crook, 91
Lion and Lamb, 89
Loaves and Fish, 88
Luther's Seal, 34
Lyre, 65
Manger and Rainbow, 13
Orders of Creation, 80
Palms and Crown with Cross, 37
Palms and Gate, 19
Peacock, 24
Plant and Sun, 29, 82
Plant, Cross, and Hearts, 67
Pomegranate, Sun, and Laurel, 22
Rainbow and People, 84
Rooster and Thorns, 21
Rocks, Plant, and Sun, 94
Shell, 52
Shepherd and Lamb, 43
Ship, Dove with Branch, and Rainbow, 45
Ship on Sea of Galilee, 95
Signposts and Cross, 76
Star, 14
Time, Talents, Treasure, 81
Tree of Life, 25
Triangle and Trefoil, 31
Triquetra, Triangle, and Sanctus, 32
Trumpets, 5
Trumpets, Cross, and Orb, 38
Triumphant Christ, 40
Virgin Mary, 9
Water, Flames, and Dove, 53